Norman Rockwell's
Boy Scouts of America®

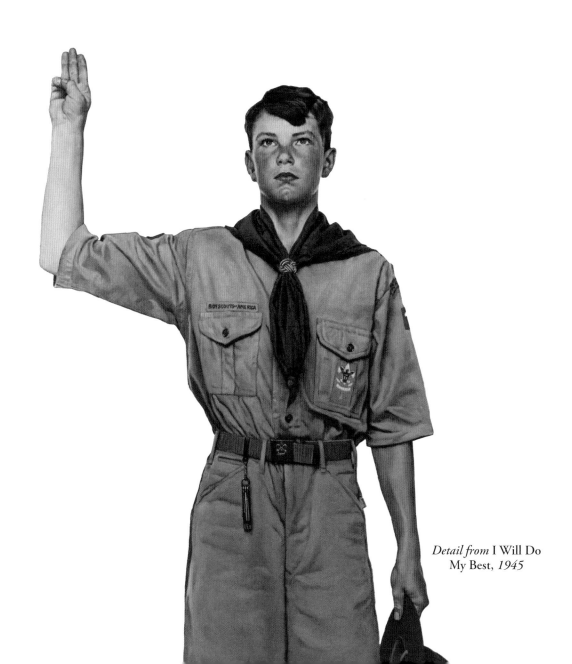

Detail from I Will Do
My Best, *1945*

NORMAN ROCKWELL'S BOY SCOUTS OF AMERICA®

BY JOSEPH CSATARI
Official Artist of the Boy Scouts of America

TEXT BY JEFF CSATARI

LONDON, NEW YORK,
MUNICH, MELBOURNE, DELHI

Designer **Stuart Jackman**
Editor **Sophie Mitchell**

First American Edition, 2009
Published in the United States by DK Publishing, Inc. 375 Hudson Street, New York, New York 10014
07 08 09 10 11 10 9 8 7 6 5 4 3 2 1
Copyright © 2009 Dorling Kindersley Limited
Text copyright © 2009 Joseph Csatari

Boy Scouts of America®, the "Universal Emblem", Be Prepared®, Boy Scout™, Boys' Life®, BSA®, Cub Scouts®,
Pinewood Derby®, Scouting®, and Venturing®, logos and uniform
insignia are either registered trademarks or trademarks of the Boy Scouts of America in the
United States and/or other countries. Printed under license from the Boy Scouts of America.
www.scouting.org

A Cataloging-in-Publication record for this book is available from the Library of Congress.
ISBN 978-0-7566-3520-6

DK books are available at special discounts for bulk purchases for sales promotions, premiums, fund-raising, or
educational use. For details, contact: DK Publishing Special Markets, 375 Hudson Street, New York, NY 10014 or
SpecialSales@dk.com

Color reproduction by Media Development and Printing Ltd (UK)
Printed and bound in China by Hung Hing Offset Printing Company Limited

Discover more at
www.dk.com

Boy Scouts of America

The mission of the Boy Scouts of America is to prepare young people to make ethical and moral choices over their lifetimes by instilling in them the values of the Scout Oath and Law. The programs of the Boy Scouts of America—Cub Scouting, Boy Scouting, Varsity Scouting, and Venturing—pursue these aims through methods designed for the age and maturity of the participants.

Cub Scouting

A family- and home-centered program for boys in the first through fifth grade (or 7, 8, 9, and 10 years old). Cub Scouting's emphasis is on quality programs at the local level, where the most boys and families are involved. Fourth- and fifth-grade (or 10-year-old) boys are called Webelos (WE'll BE LOyal Scouts) and participate in more advanced activities that begin to prepare them to become Boy Scouts.

Boy Scouting:

A program for boys 11 through 17 designed to achieve the aims of Scouting through vigorous outdoor program and peer group leadership with the counsel of an adult Scoutmaster. (Boys may also become Boy Scouts if they have earned the Arrow of Light Award or have completed the fifth grade.)

Varsity Scouting

An active, exciting program for young men 14 through 17 built around five program fields of emphasis: advancement, high adventure, personal development, service, and special programs, and events.

Venturing

This is for young men and young women ages 14 through 20. It includes challenging high-adventure activities, sports, and hobbies for teenagers that teach leadership skills, provide opportunities to teach others, and to learn and grow in a supporting, caring, and fun environment.

For more information about Boy Scouts of America or its programs visit
www.scouting.org

The Norman Rockwell Paintings

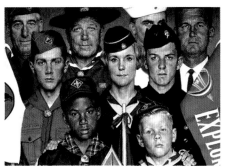

The Joseph Csatari Paintings

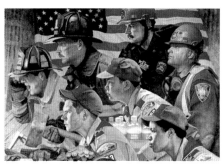

FOREWORD

If you ask an American to name an artist, it's highly likely that he or she will say "Norman Rockwell." No other painter has had a greater impact on the American people. Rockwell had an uncommon artistic gift for portraying the commonplace in life while revealing meanings that reached deep into the human heart. And his legacy began with the Boy Scouts of America.

I have been a student of Norman Rockwell's for as long as I can remember. When I was a young boy, it was my practice to bring home copies of *The Saturday Evening Post* and old Boy Scout calendars and spend hours copying Rockwell's illustrations. In high school, I saw an advertisement for the Famous Artists School correspondence course in a magazine and I immediately enrolled because Norman Rockwell was one of the featured illustrator-instructors. When I attended the Newark Academy of Art, I took a job sweeping floors in the school's museum after hours just so that I could study the original Rockwells housed there. One night, with my nose inches from a Rockwell painting, I noticed a loose paintbrush bristle stuck in a heavy stroke of paint.

Rockwell's red carriage house studio

With no one looking, I plucked it out, wrapped it in a piece of foil and put it in my wallet.

That bristle was still in my wallet many years later as I pulled into the driveway of Norman Rockwell's home in Stockbridge, Massachusetts, and parked in front of his red carriage house studio. It was 1969 and I was a young art director sent by the Boy Scouts of America to communicate to Mr. Rockwell the theme for his next Boy Scout painting. Each year, since 1925, the calendar publisher, Brown & Bigelow of St. Paul, Minnesota made a Boy Scout calendar from a Rockwell Scout-theme painting. For many years these calendars were among the top sellers in the nation.

I went to knock on his studio door when I saw a sign nearby, "Artist At Work. Please Do Not Disturb." But a piece of paper thumb-tacked to the door read, "Hello Joe, Come in. I'll be out in a coupla minutes."

Walking into Rockwell's studio, I felt like a kid in a candy store. The shelves and walls were covered with props, antiques, and mementoes from his world travels—African masks and spears, carvings, sketches, paintings, and books. There was a replica of a human skull wearing a spiked German helmet, an old printing press, and multitudes of empty frames and rolls of canvas. An old bent and paint-splattered brass bucket sat an arm's length from his chair. Rockwell's easel held a huge painting of the Apollo II space team—25 heads, from astronauts to NASA technicians.

Quickly, I looked for the "100 Percent" sign that I had read he painted in gold letters on his easel, saying, "That's what Norman expects from Norman." But it wasn't there. Instead, dangling from the ceiling on a string was a plaster angel holding a paintbrush.

Norman caught me staring at it when he came in. He pointed at the angel with his ever-present pipe and said, "I need all the help I can get."

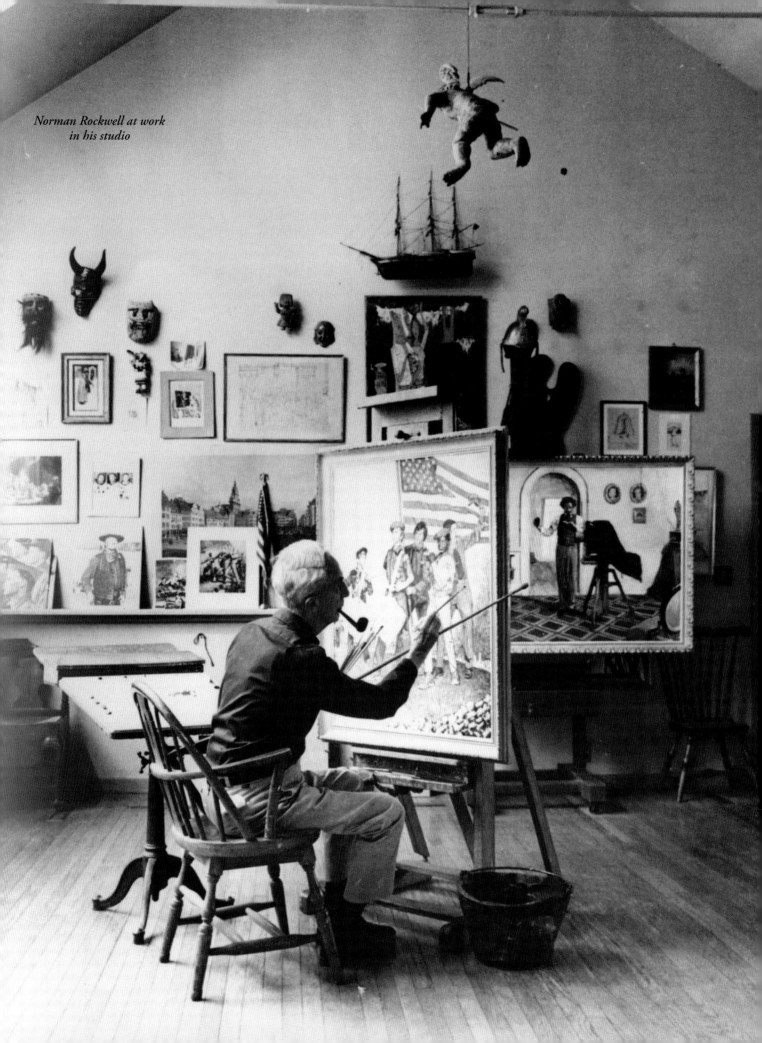

Norman Rockwell at work in his studio

We laughed and shook hands. His face glowed through a cloud of white smoke. Edgewood tobacco. I'll never forget that scent. That was the beginning of an eight-year professional relationship with the master illustrator that grew into a wonderful friendship and an even stronger admiration for his incredible talent.

To know Norman Rockwell, one needs only to look at his paintings. His illustrations were reflections of himself and his neighbors, and of America as he saw it. Norman was kind, gentle, and unassuming, and he had a wonderful sense of humor. The consummate craftsman and perfectionist, he was always looking for ways to improve a picture.

"So, Joe, do you think the heads on this picture are a bit too warm?" he asked me on that first visit, referring to the possibility that he used too much red paint in the faces of the astronauts. He wasn't just making conversation; he really wanted to know my thoughts. Later, I learned that he often asked visitors their opinion of the painting on his easel. After all, he reasoned, he was painting for them.

On one visit to Norman's studio, I took a walk over to the Old Corner House, which exhibited some of his paintings, while he took his traditional pre-lunch nap. Every day at 11 o'clock, Norman's wife Molly

Norman Rockwell and
Joseph Csatari, 1972

would knock on his studio door to remind him to take a break. "If I didn't," she told me, "he would probably work through dinner."

That day at the Old Corner House museum I walked into a room that held the *Four Freedoms*. These are among Rockwell's most famous works, four large canvases that illustrate President Franklin D. Roosevelt's 1941 message to Congress in which he described the four essential human freedoms: Freedom of Expression, Freedom from Fear, Freedom of Worship, and Freedom from Want.

I remember feeling as if I were entering church. But the reverence was broken when I noticed the men on ladders above me slapping white latex on the ceiling and I feared that they might spatter on the masterpieces below. When I got back to Norman's studio, I told him what I had seen. He took a long, thoughtful puff of his pipe, then smiled and said, "Gee, Joe, maybe they'll improve 'em."

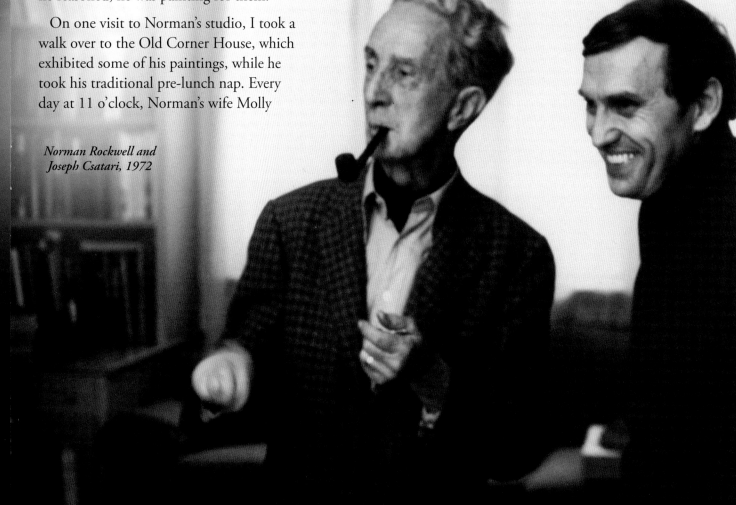

That was typical of Norman. He did not dwell on what he had done. He embraced an idea for a new painting with the enthusiasm of a Scout playing capture-the-flag. When asked which painting in his enormous body of work was his favorite, Norman often responded by quoting Picasso, "the next one."

Working with Rockwell was an amazing opportunity. I traveled with him and witnessed his kindness toward people. At photo shoots, I saw the actor who coaxed his models into just the right expression. I experienced first hand his meticulous process for creating a painting. On his last two Boy Scout calendar jobs, Norman asked me to help him work on some of the minor details—the boots, the hats, the insignias on the uniforms. Painting on the same canvas with the man I idolized as a boy was the biggest thrill of my career. And I spent hours painting those details. I wanted to make them perfect, and besides, I wanted to sit in his chair in his wonderful studio as long as I possibly could.

Norman Rockwell was in a league of master illustrators that included his own heroes, the great J.C. Leyendecker, N.C. Wyeth, and Howard Pyle. But his skill as a draftsman and his eye for detail were unparalleled. At the same time, he was a gifted storyteller and humorist, a pictorial Mark Twain.

Now, each time I sit down at my easel with a new canvas, I use all the hints Norman taught me about composition and research, about painting technique and working with the texture of the canvas, about the importance of sparing no effort to find the perfect model. To this day, I draw inspiration from the time I spent with him and from the thousands of drawings and paintings that he left us, including 49 very-

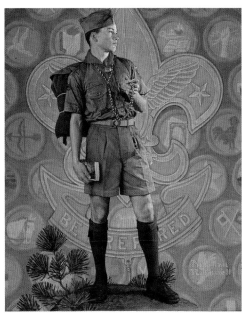

Rockwell's Tomorrow's Leader, *1959*

special ones included in this book, depicting the Boy Scout movement.

On one of my early visits to his Stockbridge studio, I asked Norman something that I had long wondered about: I mentioned that the Scout in his 1959 painting *Tomorrow's Leader* strikes a pose reminiscent of Michelangelo's *David*.

Norman smiled, "Yes, I used the pose," he said. "When you copy, be sure to copy from the best."

I guess I had the right idea when I was a boy.

Norman, who drew inspiration from the Old Masters throughout his career is, indeed, an American Master, a skillful painter whose vast body of work continues to appeal to our humor, and humanity, and hope.

Joseph Csatari

OFFICIAL ARTIST TO
THE BOY SCOUTS OF AMERICA

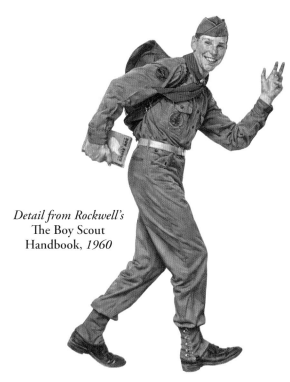

Detail from Rockwell's
The Boy Scout
Handbook, 1960

THE ART AND ARTISTS
OF THE BOY SCOUTS OF AMERICA

The 100-year history of the Boy Scouts of America is steeped in a rich tradition of important art and illustration. Scouting founder Robert S.S. Baden-Powell made skillful drawings and sketches that illustrated his Scouting ideas. Ernest Thompson Seaton, the first Chief Scout Executive, was an accomplished outdoor artist, and Daniel Carter Beard illustrated Scoutcraft books and articles for the Scout magazine, *Boys' Life.* Joseph Christian Leyendecker, Dean Cornwell, and other great illustrators have captured the vision of the Scouting movement. But since 1910 there have been only two official artists of the Boy Scouts of America, Norman Rockwell and Joseph Csatari.

Norman Rockwell was known as the Boy Illustrator. After all, he was just 17 when he illustrated his first book, *Tell Me Why Stories,* for children, just 18 years old when the Boy Scouts of America hired him in 1912 to do illustrations for the *Boys' Life* magazine, and its handbooks.

Back then, publications used very few photographs. Almost all of the pictures in magazines were drawings, so Rockwell was kept busy, and not just drawing for *Boys' Life* but for other youth magazines like *St. Nicholas, American Boy* and *Youth's Companion.* The hundreds of pen-and-inks and paintings he made of kids doing kid things for those magazines helped him to hone his craft and develop his storytelling skill, which throughout his career, and especially through the 322 cover paintings he made, over 47 years, for *The Saturday Evening Post,* would firmly establish him as the most beloved and influential artist in American history.

Rockwell on the steps of his Stockbridge studio.

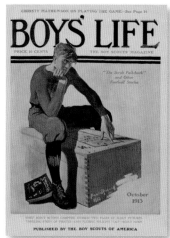

Rockwell's second Boys' Life *cover, October 1913.*

Although Rockwell served as *Boys' Life* art director for only a few years, his association with the Boy Scouts of America was lifelong. He made more than 50 paintings and hundreds of drawings for the Scouts in a 64-year relationship with the organization.

Boys' Life Magazine

In 1912, the Boy Scouts of America purchased *Boys' Life* magazine from publisher George S. Barton of Boston. The publication, a twice-monthly, had launched a year

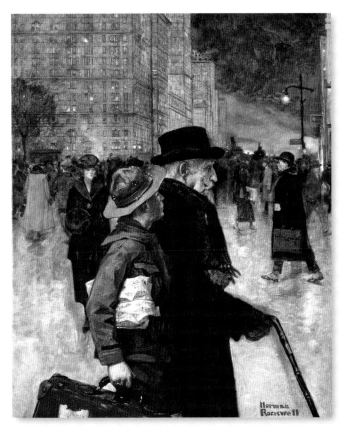

The Daily Good Turn, *1918*.

earlier as the *Boys' and Boy Scouts' Magazine* and its target market included several youth organizations including Ernest Thompson Seton's Woodcraft Indians, Daniel Carter Beard's Sons of Daniel Boone, and the Boy Scouts of America.

In the fall of 1912, the gangly 18-year-old Rockwell, with portfolio in hand, climbed the steps to the Manhattan office of the Boy Scouts of America and showed his illustrations to *Boys' Life* editor Edward Cave. The editor was impressed and gave Rockwell his first paid assignment: choose three incidents from a story by Stanley Snow and illustrate them in charcoal. Not long after that day, Cave asked Rockwell to make pen-and-ink drawings for a handbook on camping called *The Boy Scout's Hike Book*. Cave was so pleased with his work, he hired Rockwell as the magazine's chief illustrator and first art director, a position that paid a salary of fifty dollars per month. Rockwell produced in excess of 200 illustrations for *Boys' Life*. He went to the magazine office once a week to interview artists, assign illustrations, and approve the finished work. "The extraordinary part of it was that I had to okay my own

work," quipped Rockwell in his autobiography. "That part of being an art director wasn't difficult."

Prior to the advent of the four-color printing process, most of these cover illustrations were painted in black or brown and white and red and were typical of the work he published in other magazines such as *St. Nicholas, American Boy,* and *Youth's Companion.*

The Boy Scout Calendar

In 1916, Rockwell left *Boys' Life* to embark on a freelance career and set his sights on *The Saturday Evening Post,* the weekly magazine that was known for its famous cover artists, such as J.C. Leyendecker, Howard Chandler Christy, and N.C. Wyeth.

But in1925, an idea by Brown & Bigelow, one of the nation's largest calendar publishers based in St. Paul, Minnesota, rekindled Rockwell's association with the Boy Scouts of America. The idea was to produce a series of calendars depicting the country's fastest

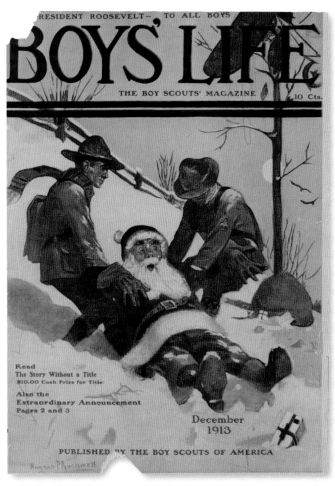

December 1913

Norman Rockwell's Scout art appeared on popular calendars from 1924 to 1976.

most calendars today, the Brown & Bigelow reproductions were big, some measuring 22-by-44 ½ inches because they were used in large public buildings and businesses, and in homes where the Boy Scout calendar may have been the family's only significant piece of art on the walls. The Brown & Bigelow Scout calendars became the best-selling calendars in the nation and introduced Norman Rockwell and Boy Scouting to millions of Americans. In a 1945 profile of Rockwell in *The New Yorker* magazine, writer Rufus Jarman reported that statisticians estimated Rockwell's Boy Scout calendars received one billion six hundred million viewings on any given day.

These highly detailed oil paintings had more than one life. Following their publication for the beginning of a new year, the calendar painting was then used to illustrate the February cover of the *Boys' Life* magazine. Rockwell's Boy Scout calendar paintings spanned 52 years until 1976, when he retired from his Scout work, and Joseph Csatari took over the commission. The calendars were published until 1990–a total publishing span of 66 years. Many of the original paintings can be seen today at the National Scouting Museum in Irving, Texas.

growing youth organization, one that would appeal to every boy in the country and to their fathers and mothers. Brown & Bigelow presented the proposal to Chief Scout Executive James E. West, who recognized this tremendous opportunity to promote the image of Scouting throughout the country. These calendars were sponsored by banks, department stores, car dealerships, oil companies, pharmacies, realtors, and service stations, which gave them away to customers. Unlike

Norman Rockwell, Illustrator

The great American illustrator Howard Pyle used to tell his students to climb over the frame and put themselves

1914

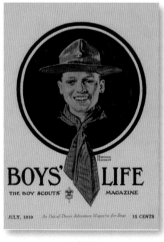

1919

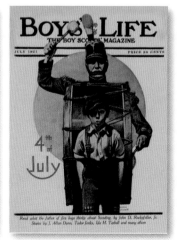

1921

1929

1934

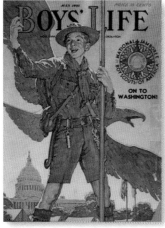
1935

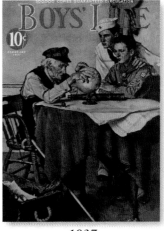
1937

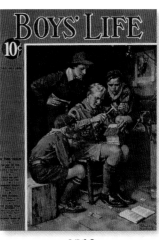
1938

right into their pictures. No artist practiced that lesson more skillfully than Norman Rockwell.

"You must feel love or hate or humor much more intensely than you can expect the people who see your pictures to receive the impression," Rockwell wrote in 1949. "This ability to 'feel' an emotion so intensely that you can project your feeling to someone else is one of the real joys of creative work."

Norman Rockwell possessed a brilliant ability to fill his paintings with emotion—with tenderness, sympathy, and warm humor. He was and remains America's most beloved artist because his paintings spoke directly to her people. He wasn't an artist whose work people had to view in art galleries and museums. His illustrations came right into their homes through magazines, advertisements, and calendars. And they captured moments of life that were familiar to them.

Rockwell is, perhaps, best known for the covers he created for the *Post*, arguably the most popular magazine of its day. He is also known through the thousands of other oil paintings and drawings he completed for some 70 different magazines, book covers, print advertisements, and portraits of politicians, actors, and other celebrities. His fame was unparalleled in contemporary art. And, yet, throughout his amazing career he held a warm spot in his heart for the Boy Scouts of America.

"For me, Scouting has always encouraged the best from each boy who is a member," Rockwell wrote in 1974. "This is the feeling that I've really enjoyed conveying in my paintings over the years."

Detail from Rockwell's
Forward America, *1951*

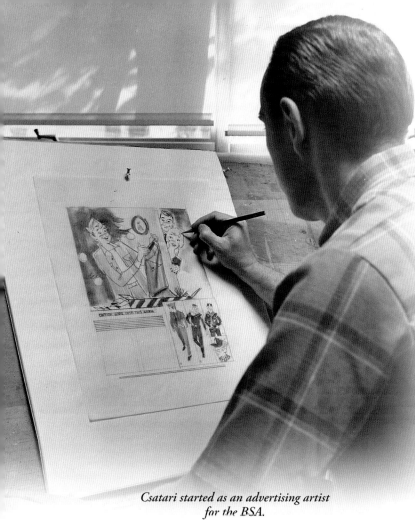

Csatari started as an advertising artist for the BSA.

my admiration for the Boy Scout program. It has remained with me ever since."

Norman Rockwell was eighty years old in 1974 when he completed his last Boy Scout calendar, *The Spirit of 1976,* for the nation's bicentennial celebration. In February 1977, President Gerald Ford awarded Rockwell the Presidential Medal of Freedom for his "vivid and affectionate portraits of our country."

Norman Rockwell died at his home in Stockbridge on November 8, 1978 at the age of 84. Troops of Boy Scouts in crisp khaki uniforms lined the steps of the church at his funeral.

Joseph Csatari, Illustrator

In 1975, when Rockwell retired, Brown & Bigelow and the Boy Scouts of America asked Joseph Csatari, Norman's friend and art director of eight years, to continue the annual Scout painting in the Rockwell tradition.

Csatari was born to Hungarian immigrant parents John and Emma on February 20, 1929 in South River, New Jersey. His earliest recollection of drawing was occupying himself while sitting in the cloth bin at the dress factory where his mother sewed. Doodling cartoons to pass the hours developed in him a love of creating with pencil and paper that blossomed years later through the inspiration of his brother Johnny, an aspiring artist. It was John Csatari who first introduced his younger brother to the *The Saturday Evening Post* covers and Boy Scout calendars of Norman Rockwell.

To show its appreciation to the first artist of the BSA, in 1938 the Boy Scouts of America presented Norman Rockwell with the Silver Buffalo award, the organization's highest honor for distinguished service to boyhood.

Rockwell summed up his feelings when he wrote, "In 1913, the movement in America was only three years old. I was 19 at the time when I became art director for *Boys' Life.* My love for boys in the outdoors quickly merged with

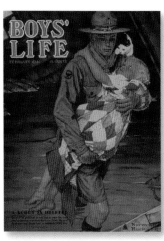

1941

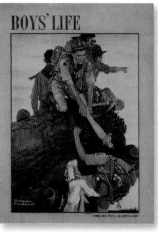

1947

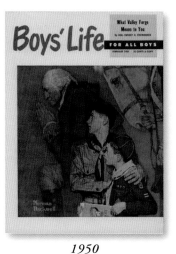

1950

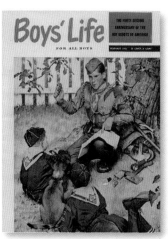

1952

Csatari's teachers recognized the youngster's talent and encouraged him throughout grade school. He was an athlete who ran track and played football, he acted in plays in school and at the First Hungarian Reformed Church and even crooned with a quartet on the local radio station. He joined the Boy Scout Troop 4 in South River, still his hometown, with his best friend Frank Koos. "We were so proud of our uniforms," he recalls, "Frank and I walked all over town looking for American flags just so we could salute."

During high school, Csatari enrolled in the Famous Artists School correspondence course operated by some of the best illustrators of the day, including founder Albert Dorne, his idol Rockwell, the Hungarian artist Stevan Dohanos, and others. Csatari devoured the coursework. At the same time, he would continue to copy Rockwell's *Post* covers and Scout calendars for practice.

Detail from Csatari's Scouting Through the Years, *1978*

While financial hardship forced brother Johnny to abandon his art dreams to help support the family, the youngest of the four Csatari children was fortunate for the opportunity to go to art school following graduation from high school. He attended the Newark Academy of Art. There he honed his skill as a draftsman in comprehensive courses in human anatomy, live nude class, and painting. His talent for portrait painting, which he has painted throughout his career, emerged at Newark. The dean of the art school thought that his portrait of President Dwight D. Eisenhower was so well made, he arranged for Csatari to present it to Ike at the White House. "Eisenhower was so charming and his smile was ear to ear. You couldn't help but like him," Csatari recalls. "Norman once told me that President Eisenhower had the most expressive face he had ever painted. And it certainly was."

Csatari went on to Pratt Institute in Brooklyn to study

1956

1958

1959

1965

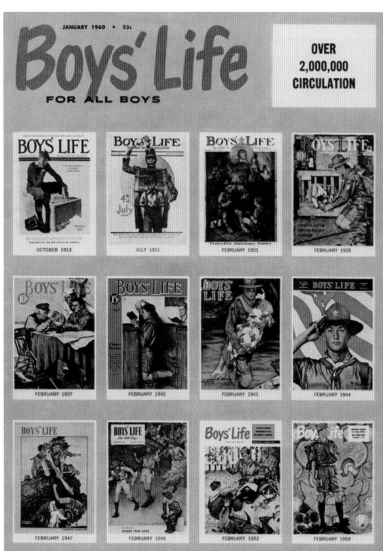

To mark the 50th year since the founding of the Boy Scouts of America in 1910, the January 1960 cover of Boys' Life *featured a sampling of Rockwell Scout paintings beginning with the 1913 cover. The circulation of the magazine had grown from 6,000 subscribers when the BSA bought it in 1912 to more than two million at its peak of popularity in 1960.*

advertising design. To help pay for school, he painted designs on neckties and sold them on Fifth Avenue in New York City. After a year, he had two art job offers, one at the young girls' magazine *Seventeen*, the other as a layout artist in the advertising department of the supply division of the Boy Scouts of America. He chose the latter position thinking that he might someday have the opportunity to meet his boyhood idol Norman Rockwell, the official Boy Scout artist.

In 1969, as art director in the advertising department of the BSA's Supply Service, Csatari began working closely with Norman Rockwell on his annual Scout calendar painting. It was Csatari's job to interpret themes chosen by Boy Scout executives for the painting and make rough sketches and layouts to guide Rockwell. Once Norman selected a concept, Joe would round up models and shuttle them up to Rockwell's studio in Stockbridge, Massachusetts, or some woodsy location for a photo shoot. Rockwell appreciated Csatari's ability to do the blocking and tackling for him on his Scout work to ease his load. After all, Rockwell was busy even late in his career. The famous artist was always in demand and he rarely said no to a job, often, Csatari says, because he worried that they might stop

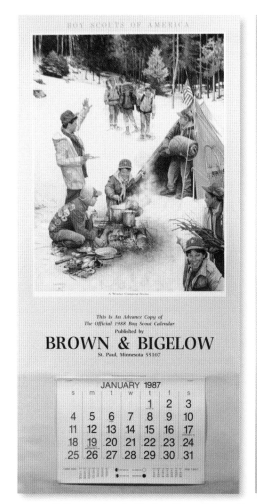

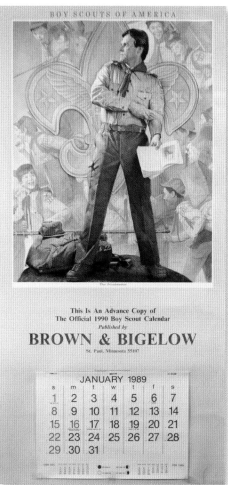

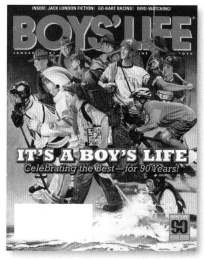

Following in the Rockwell tradition, Csatari made Scout paintings for Brown & Bigelow calendars from 1977 to 1990.

Csatari's January 2001 cover of Boys' Life.

coming. In 1973, Csatari took on another role with the Boy Scouts of America as art director of *Boys' Life* magazine, a position his mentor Rockwell held in 1912.

During the last two Scout calendars that Rockwell painted, Csatari made frequent visits to Stockbridge to assist the aging artist. His health was failing; his hands were no longer steady enough to execute the detail characteristic of his earlier work. "He'd ask me to paint in the boots or insignia or other details," Csatari says. "That was the thrill of my life—even though I know he went back over what I had done."

Two years after taking over Rockwell's annual Scout painting commission for the Boy Scouts of America, Csatari left the BSA staff to begin a freelance career as an illustrator and portrait artist. During the 1980s, he produced illustrations for the new *Saturday Evening*

Post, Time magazine, *Readers' Digest, McCall's, Field & Stream,* and *Outdoor Life* among others, as well as a steady stream of book covers. But in his studio you'll always find sketches, drawings, photographs, and props for Boy Scout paintings. In 2005, the Boy Scouts of America honored Csatari with its highest award for adult leadership, the Silver Buffalo, for his service to youth through his artwork and volunteering in civic organizations and as assistant Scoutmaster for Troop 83 of South River, New Jersey, his hometown.

While Csatari dabbles in making fine art landscapes and watercolors of animals and birds, it is people and their stories he most enjoys illustrating.

"I love painting people because, well, we were all made in God's image," he says. "And there's something spiritual about the whole process that I find extremely fulfilling."

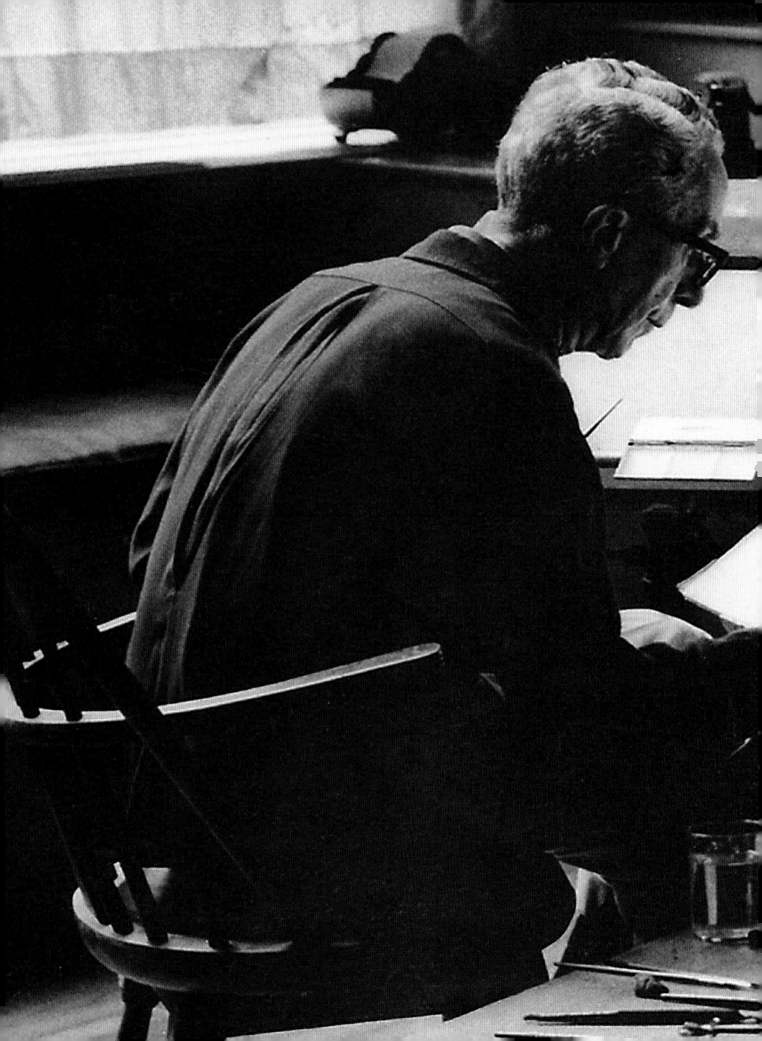

THE NORMAN
ROCKWELL PAINTINGS

1913

SCOUTING MAKES REAL MEN

This painting showing a Scout signaling the letter "L" with semaphore flags was never used as a calendar. It was one of four Scout-themed works that Rockwell made for *The Red Cross Magazine* in 1918, which were later donated to the Boy Scouts of America.

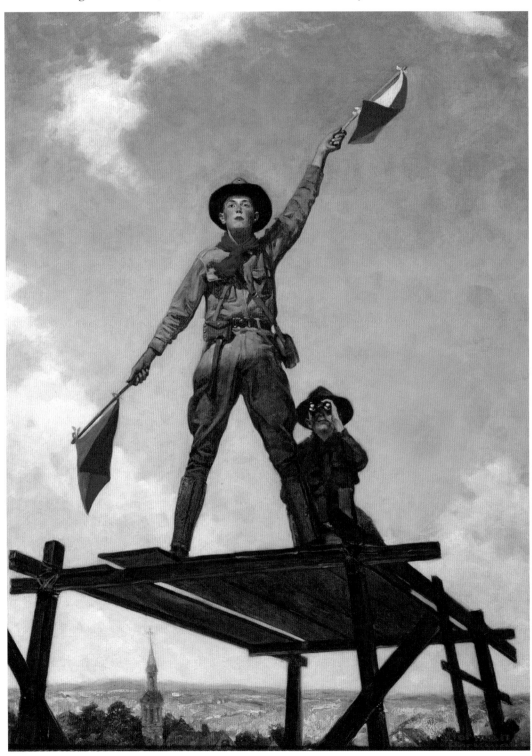

1925

A GOOD SCOUT

Rockwell believed that a good illustration should contain an element of humor and pathos: "The most popular idea is one that makes the reader want to smile and sigh at the same time." This painting of a Boy Scout bandaging a puppy's paw does just that.

For Norman's first Scout calendar, Brown & Bigelow used this image, an existing painting called *A Red Cross Man in the Making* that Rockwell made for the cover of *The Red Cross Magazine* in 1918. The St. Paul, Minnesota calendar publisher made a practice of hiring some of the finest illustrators of the day, including Maxfield Parrish, Frank B. Hoffman, Dick Bishop, and Andrew Loomis. Norman Rockwell was a natural addition, perfect for the Boy Scout concept given his past relationship with the organization and his experience painting youth. Brown & Bigelow sold its calendars to businesses, which gave them away to customers and clients as a promotion.

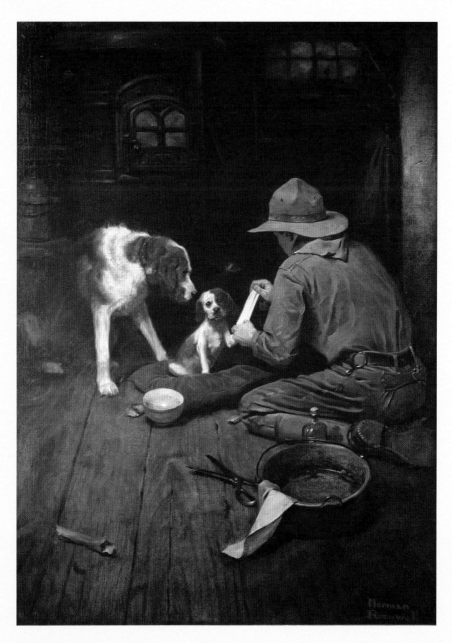

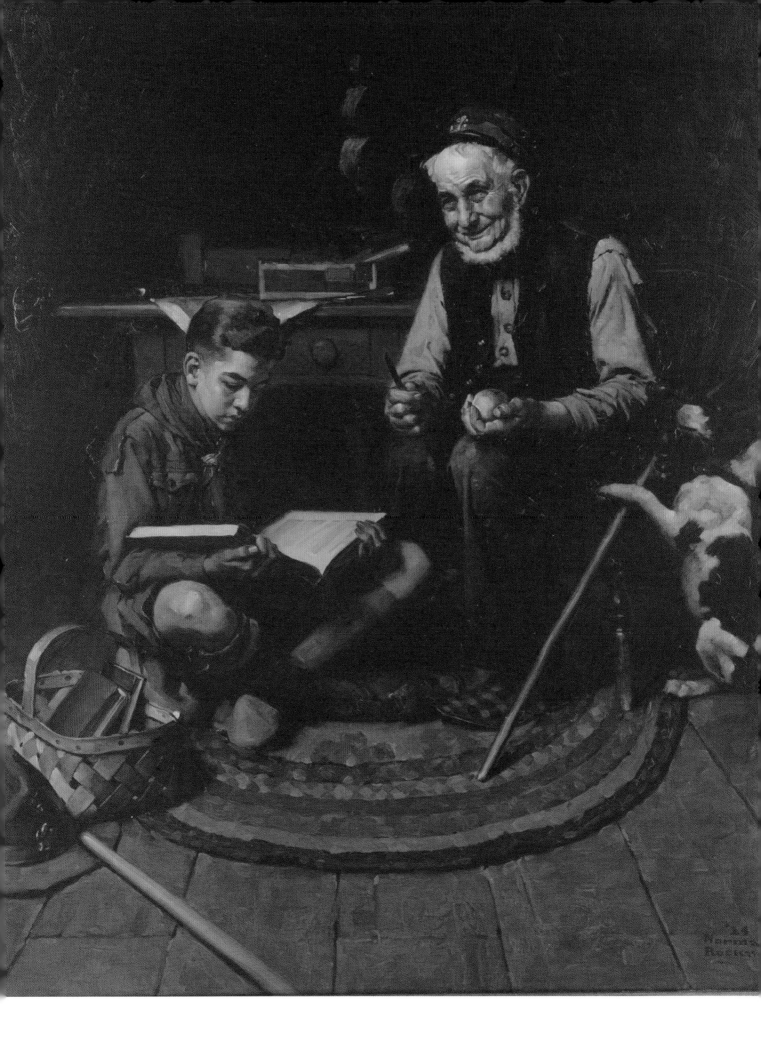

1926

A GOOD TURN

Brown & Bigelow saw the tremendous potential of teaming the country's premier calendar maker with America's top artist and the number one boys' organization, so it needed a plan to accommodate the two-year timeframe to properly develop the calendar and have the sales force to market it. Rockwell would complete the Scout painting two years in advance of the calendar date. The same painting, then, would be used as the cover of the February issue of *Boys' Life*.

The 1926 calendar *A Good Turn*, painted in 1924 was the first that Rockwell created exclusively for the Boy Scouts of America and Brown & Bigelow. The Boy Scouts rejected Rockwell's original sketch of a Scout doing a good turn for a circus acrobat, preferring this composition showing a Scout reading to an old sea captain. Rockwell surprised the Scouts by announcing that he would do the project (and the 1927 painting as well) without compensation "as a labor of love," in appreciation for the start they had given him in the illustration business.

1929

SPIRIT OF AMERICA

In the original charcoal sketch for this illustration, Rockwell set a Boy Scout against a background of figures from American history—an Indian, a pioneer, George Washington, Abraham Lincoln, Theodore Roosevelt and a conquistador. When he began the final painting in May 1927, the world was captivated by the news of Charles Lindbergh's historic solo non-stop flight across the Atlantic in *The Spirit of St. Louis.* So, Rockwell decided to replace the conquistador behind the Scout with the profile of Lucky Lindy wearing flying goggles strapped to his forehead. In addition to being used on the February cover of *Boys' Life*, the 1929 calendar served as the cover of the new Scout *Handbook For Boys.*

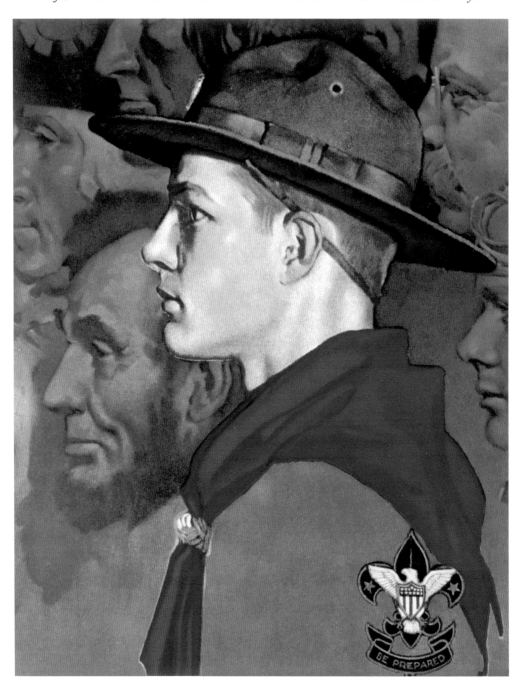

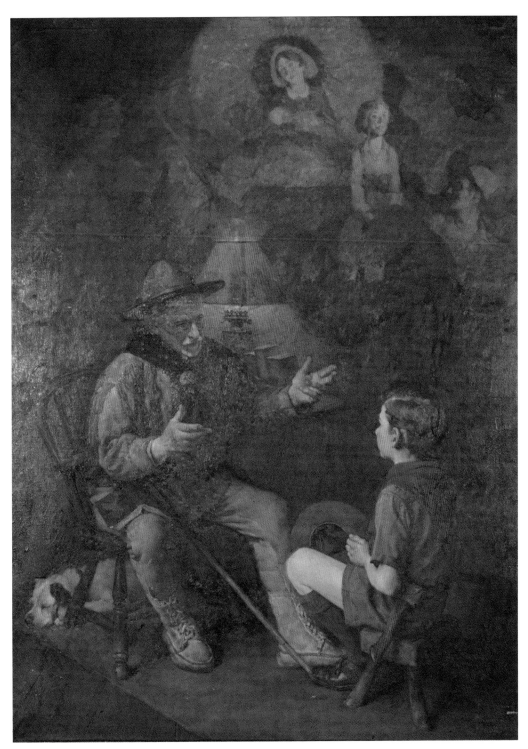

1931

SCOUT MEMORIES

Daniel Carter Beard, shown in his trademark buckskin outfit, was nearly 80 when Rockwell portrayed him telling the story of pioneers heading west in covered wagons to a Scout. An influential member of the early Boy Scout staff, Beard was an associate editor of *Boys' Life*, an artist who illustrated books for Mark Twain, and the founder of his own youth organization called the Sons of Daniel Boone.

1932

A SCOUT IS LOYAL (right)

One of Rockwell's most dramatic calendar illustrations shows sunlight bathing a contemplative Boy Scout while a ghostlike image of general George Washington and a soaring bald eagle appear in the cloud-shrouded background. The painterly quality of the majestic figures in the clouds is reminiscent of one of Rockwell's favorite illustrators, N.C. Wyeth.

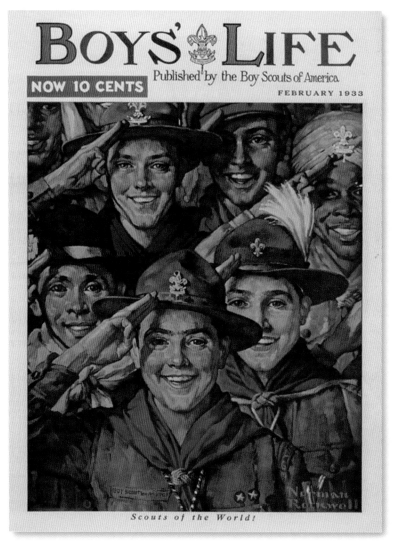

1933

AN ARMY OF FRIENDSHIP (above)

This is the first of three paintings Rockwell completed on the theme of the global brotherhood of Scouting. It celebrated the Fourth Scout World Jamboree held in Hungary. Among countries represented are Great Britain, Poland, the Sudan, and Siam. The boy with the grass plume in his hat is the Hungarian Scout.

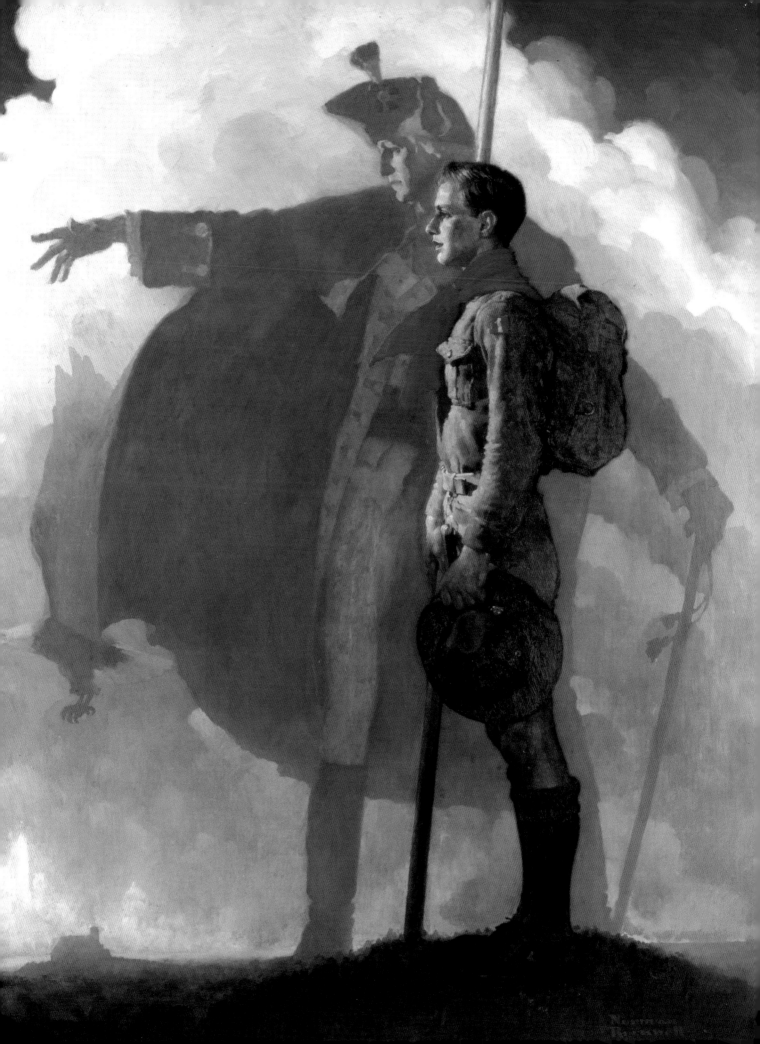

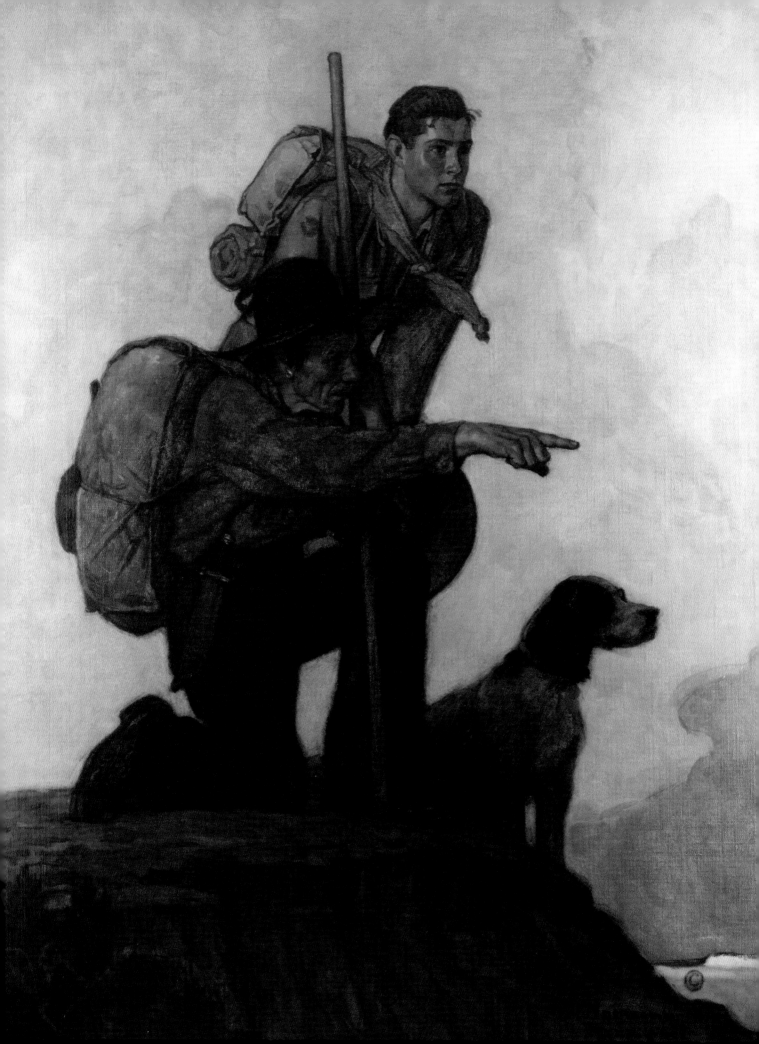

1934

CARRY ON

In the 1930s, the Boy Scouts of America created a new program, Senior Scouts, in an attempt to retain older boys. Rockwell illustrated one of these Scouts learning the ways of an old tracker in this striking picture. The young man's ruddy complexion, stylish hair, and athletic good looks suggests the influence of Joseph Christian Leyendecker, one of the most celebrated artists of America's Golden Age of Illustration.

A friend and hero of Rockwell's, Leyendecker established the prototype of the stylish American male promoting clothing fashions by introducing the iconic Arrow Collar Man into the American psyche through illustrated advertisements for the Arrow Shirt Company. Leyendecker pioneered the advertising maxim that to sell a product, you need to sell a youthful, attractive lifestyle. And Rockwell's Scouts were characterized by this polished ideal, as well. After all, he was introducing an image of the Boy Scouts of America to the American people. Rockwell learned from Leyendecker that the modern magazine cover functions as a poster whose purpose is to engage the viewer and sell an idea or tell a story in just a few seconds as the reader browses the newsstand.

1935

A GOOD SCOUT (right)

The personal mess kit used by Scouts today hasn't changed much from the 1930s model that this well-outfitted patrol leader is using to water a dog in a crate aboard a railcar. Clipped to the boy's belt are his Scout folding knife and a sheathed hatchet. The Scout who modeled for this illustration is Robert West, the son of Chief Scout Executive James E. West.

ON TO WASHINGTON (below)

This illustration appeared on a poster promoting the first National Jamboree held in Washington, D.C., in August 1935, as well as the cover of *Boys' Life* magazine.

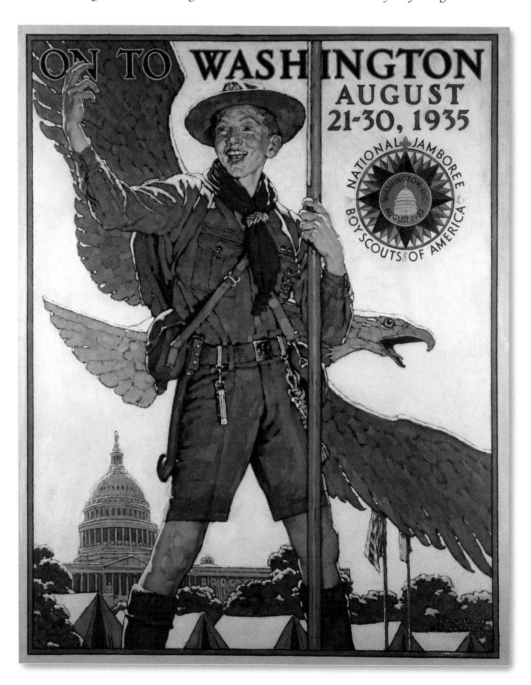

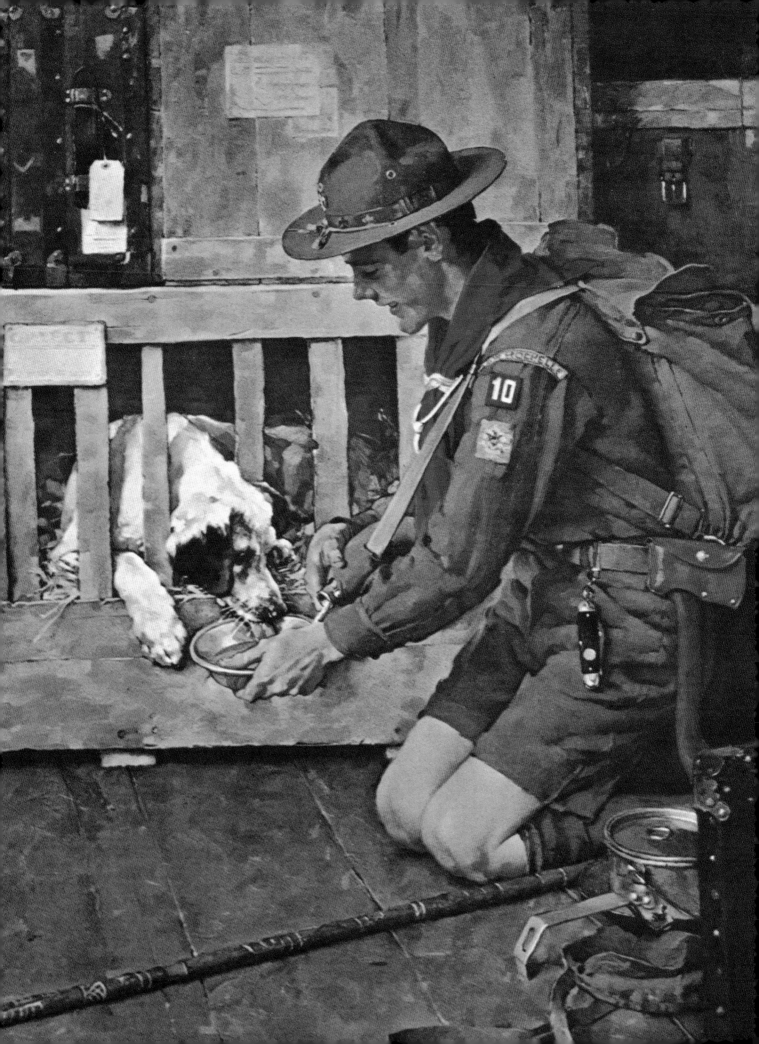

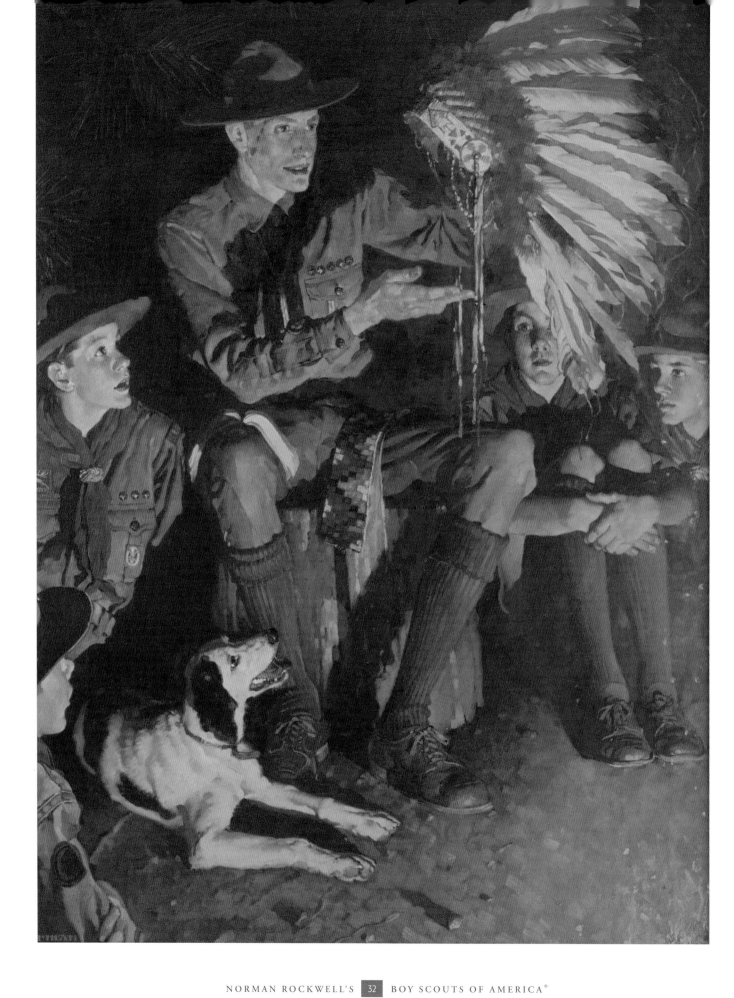

1936

THE CAMPFIRE STORY

The nightly campfire is a magical time at Scout camp, and Rockwell captures it beautifully by playing lights against darks in this dramatic image. Notice the gaze of the mesmerized boy under the Indian headdress; the Scout seems to be envisioning the Scoutmaster's tale come to life. Also note the differences in the colors of the khaki clothing. The artist uses more green in the Scoutmaster's uniform to draw the eye to the aesthetic center of the painting.

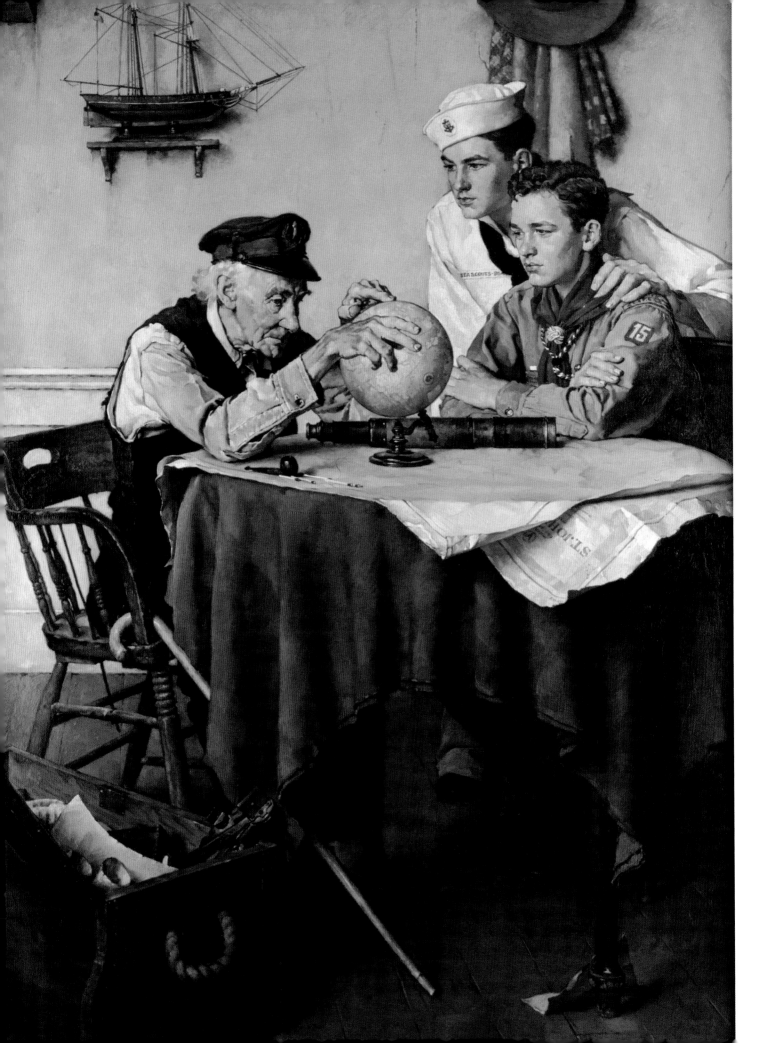

1937

SCOUTS OF MANY TRAILS

A common storyline in Rockwell's Scout calendar paintings is the passing down of wisdom and skills to youth as we see in this image of the elderly sea captain, Boy Scout, and Sea Scout. Notice the details in this work, the ship model on the wall, the sextant in the sea chest, and the map of the waters surrounding St. John in the Virgin Islands on the table. Props were essential to Rockwell's creative process. He maintained that every object in the picture should contribute to the authenticity of the story and must be historically accurate. Otherwise, he'd get letters from people who found something amiss with one of the props.

1938

AMERICA BUILDS FOR TOMORROW

America Builds for Tomorrow is the first Rockwell to feature Cub Scouting, which began in the early 1930s as a program for younger boys. The older boy teaching Scoutcraft skills to younger boys is a key theme in Scouting and one that Rockwell returned to time and again. But even in the most commonplace of scenes, Rockwell builds thoughtful details into his image that make the overall composition unique. Here, the image of the Scout tapping a nail into the roof of the birdhouse is mimicked by the woodpecker drilling into a tree shown in the poster on the back wall. Rockwell put much effort and thought into the creation of these details; every inch of the canvas was important to his purpose, and even the uniform patches were carefully considered. The Scout's shoulder patch indicates he is in the Fox Patrol and the star patch under his right arm shows that he participated in the 1935 National Scout Jamboree.

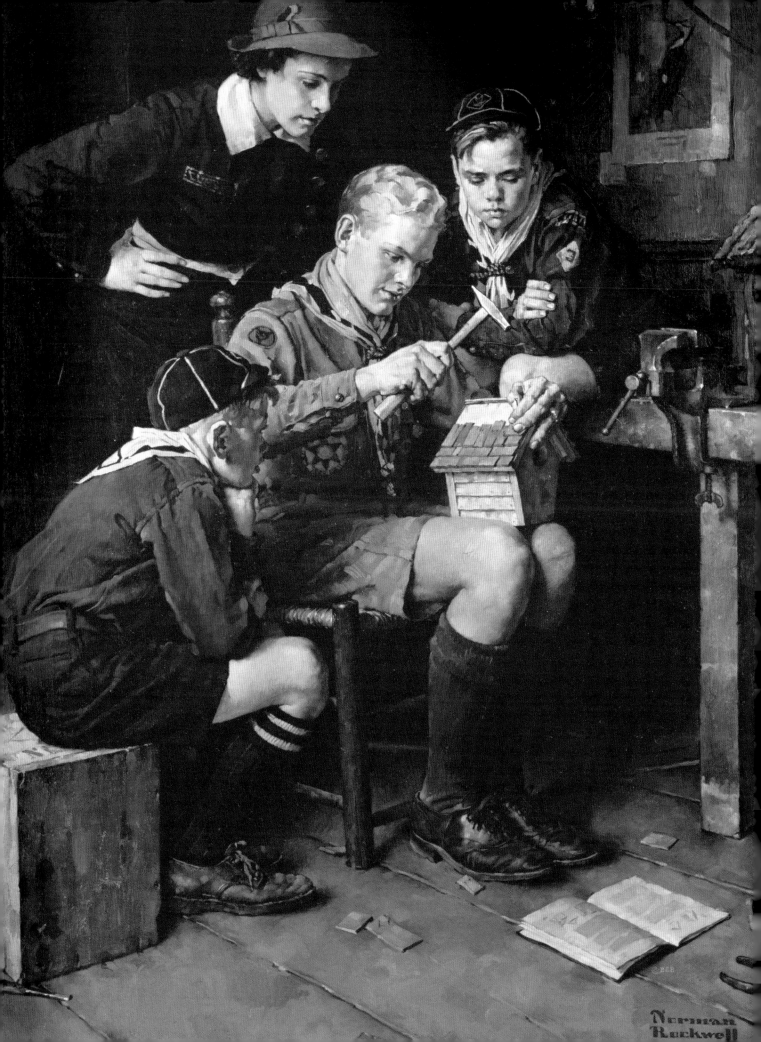

Norman Rockwell

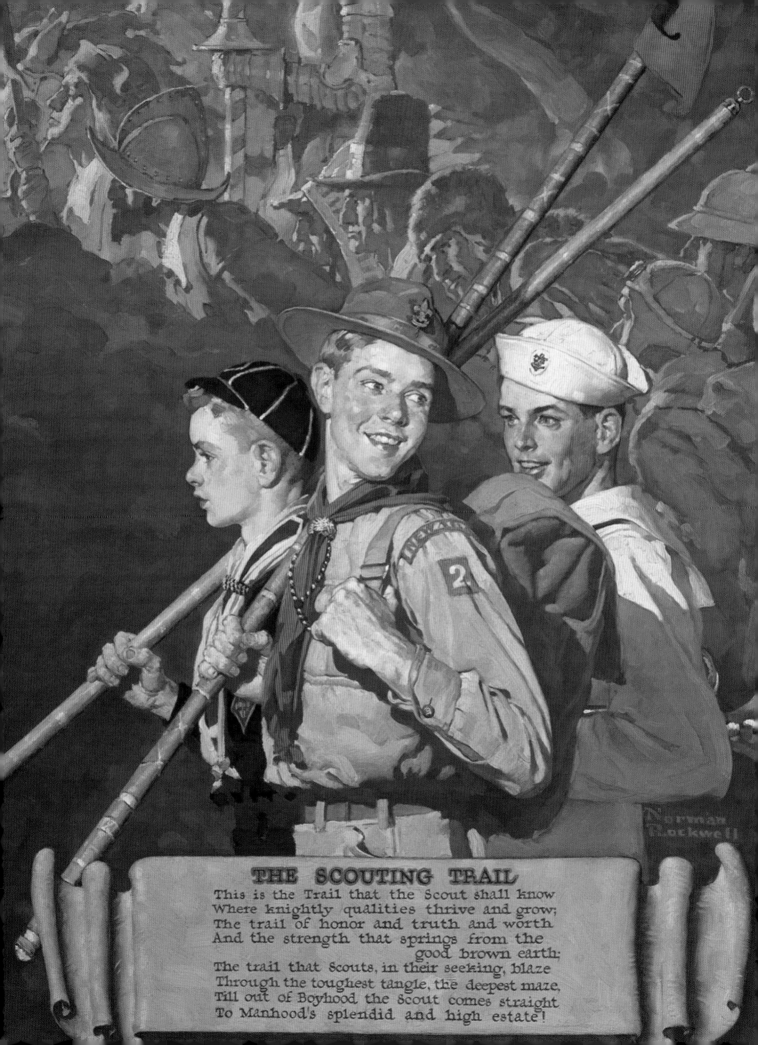

THE SCOUTING TRAIL
This is the Trail that the Scout shall know
Where knightly qualities thrive and grow;
The trail of honor and truth and worth
And the strength that springs from the
 good brown earth;
The trail that Scouts, in their seeking, blaze
Through the toughest tangle, the deepest maze,
Till out of Boyhood the Scout comes straight
To Manhood's splendid and high estate!

1939

THE SCOUTING TRAIL

The Scouting Trail is the path that all honorable knights, conquistadors, pioneers, and explorers travel in their quest for growth and knowledge. Rockwell places a modern day Cub Scout, Boy Scout, and Sea Scout on that path blazed by the ghosted images of their forefathers in the background. The artist carefully represents all the intricacies of the boys' uniforms and neckerchiefs, including the Boy Scout's decoratively carved patrol flagpole.

1940

A SCOUT IS REVERENT

Through his calendar paintings, Rockwell illustrated to the nation the mission of the Boy Scouts of America to prepare young people to make ethical and moral choices by instilling in them the values of the Scout Oath and the 12 points of the Scout Law:

A Scout is trustworthy, loyal, helpful, friendly, courteous, kind, obedient, cheerful, thrifty, brave, clean, and reverent.

The final point in the Scout Law—A Scout is Reverent—requires a Scout to be faithful in his religious duties and respectful of others' convictions in matters of custom and religion. So significant is duty to God to the Scout mission that Rockwell portrayed Scouts engaged in worship three times in his 50-Scout calendar painting series.

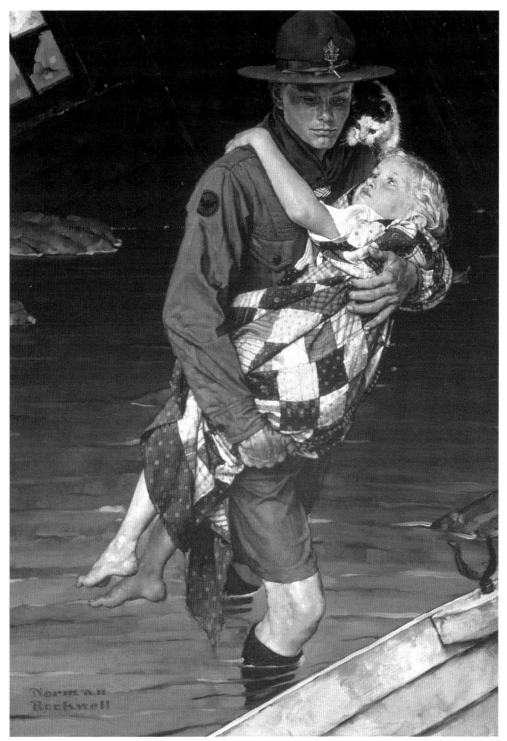

1941

A SCOUT IS HELPFUL

The minor elements in this painting are essential for telling the story of a Scout's duty to help in times of need: the broken window of the flooded house in the upper left corner, the oarlock of the rowboat, the warm patchwork quilt wrapped around the child, and even the rescued kitten sheltered under the brim of the Scout's campaign hat.

1943

A SCOUT IS FRIENDLY

Rockwell illustrates another of the 12 points of the Scout Law in this calendar painting that shows a Scout helping a traveling family with map directions. Boy Scouts are encouraged to do a "Good Turn" daily, a practice, which can be traced back to the founding of the Boy Scouts of America when a British Scout refused a tip for helping American businessman William D. Boyce to find his way in a London fog (below on 1919 *Boys' Life* cover).

Over the 100-year history of the Boy Scouts of America, the organization has frequently called upon its membership to do a National Good Turn. In 1917, the day after the United States declared war on Germany, the BSA pledged its support with the slogan "Every Scout to Feed a Soldier," which urged members to plant vegetable gardens. In addition, the BSA cooperated with the U.S. Navy by organizing Scout costal patrols to watch for enemy ships. The Scouts also sold war savings stamps and Liberty Loan bonds, and collected 100 train carloads of peach pits and nut hulls, which were burned to make charcoal for gas mask filters. During the Great Depression years when he was President (1933-1945), Franklin D. Roosevelt asked Boy Scouts to collect clothing and household furnishings for the needy. In 1944, Scouts planted 184,000 Victory Gardens, and collected 750 tons of milkweed floss for use in life jackets. And on and on. Today, the Scouting for Food National Good Turn collects nearly a million cans of nonperishable food for people in need every year.

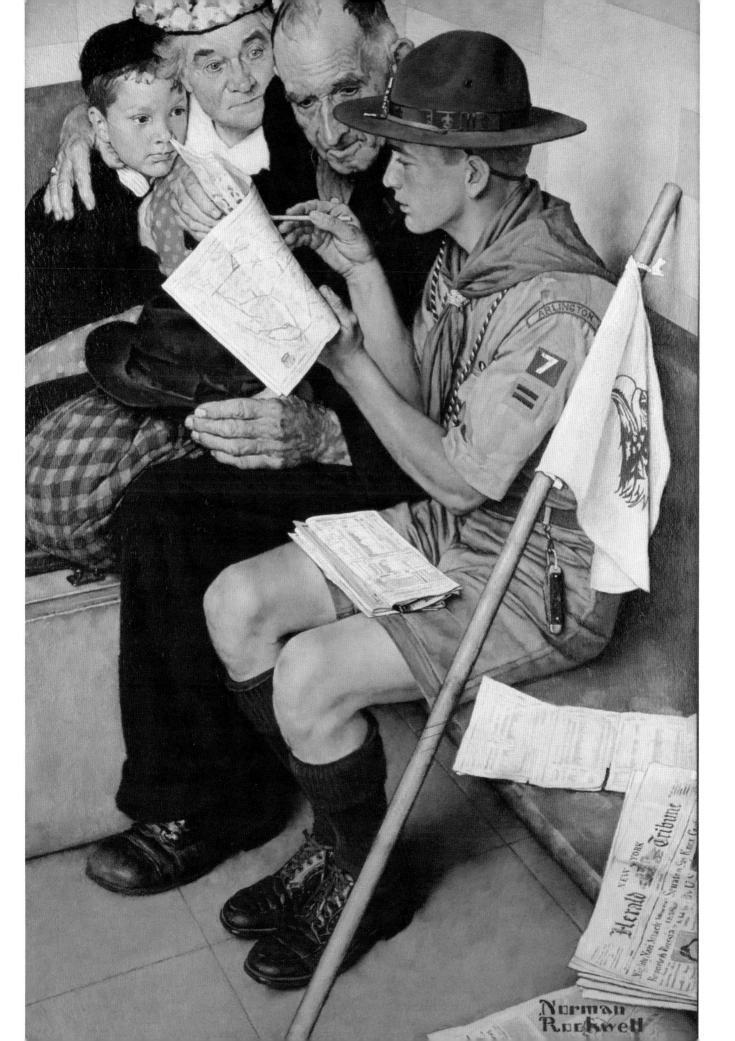

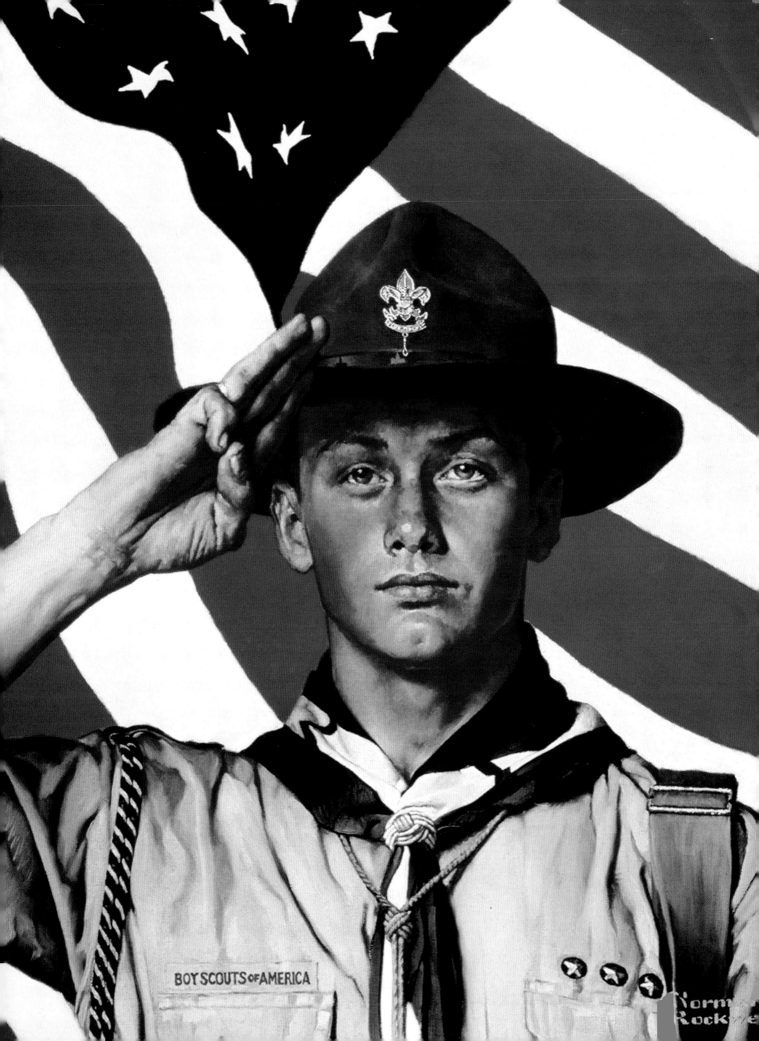

1944

WE, TOO, HAVE A JOB TO DO

During World War II, the Boy Scouts supported the war effort by collecting aluminum and rubber, raising food in Victory Gardens, acting as fire watchers and dispatch bearers for Civil Defense and distributing war bond posters and pamphlets. To express the Boy Scouts' commitment to the American cause, Rockwell created this painting of a First Class Scout flanked by the American flag. Rockwell completed this painting in 1943, just after finishing *The Four Freedoms*. Among his most famous paintings, *Freedom of Speech, Freedom From Want, Freedom of Worship*, and *Freedom from Fear* illustrated Franklin D. Roosevelt's four essentials for human happiness, which galvanized the country in a speech the president made before Congress. *The Four Freedoms* formed the centerpiece of the government's campaign to sell war bonds. A touring exhibition of the paintings is credited with raising over $130 million for the war effort. But creating these masterpieces took an emotional and physical toll on Rockwell, and they set him behind on his Scout calendar commission. Exhausted, he finished this Scout painting and sent it off to BSA headquarters still wet, and took a rare afternoon off. That evening his studio burned to the ground, the flames consuming some of his beloved antiques and props as well as many paintings and sketches. Rockwell believed he must have knocked hot ash from his pipe onto a sofa while closing up his studio for the night.

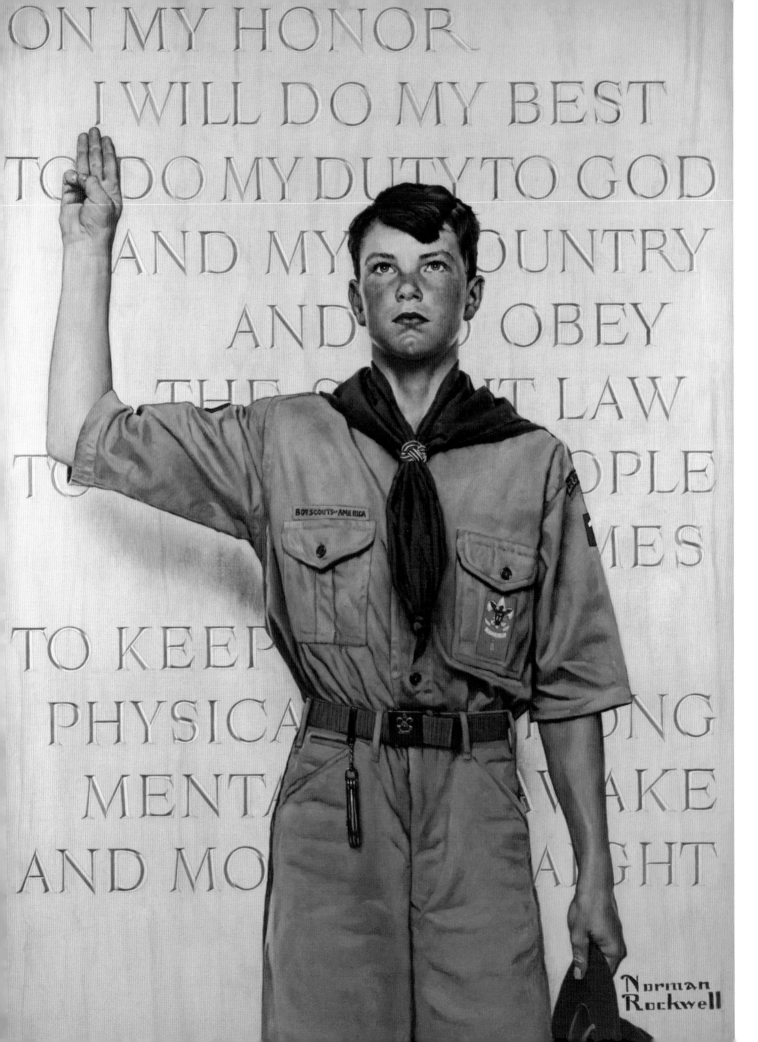

1945

I WILL DO MY BEST

A First Class Scout lifts his right hand and forms the three-finger Scout sign, with thumb over the little finger. This is the sign of Scouting used throughout the world. In the United States, Scouts make this sign before meetings and outings when pledging to fulfill the Scout Oath:

On my honor,
I will do my best
To do my duty to God and my country
To Obey the Scout Law;
To help other people at all times;
To keep myself physically strong, mentally awake, and morally straight.

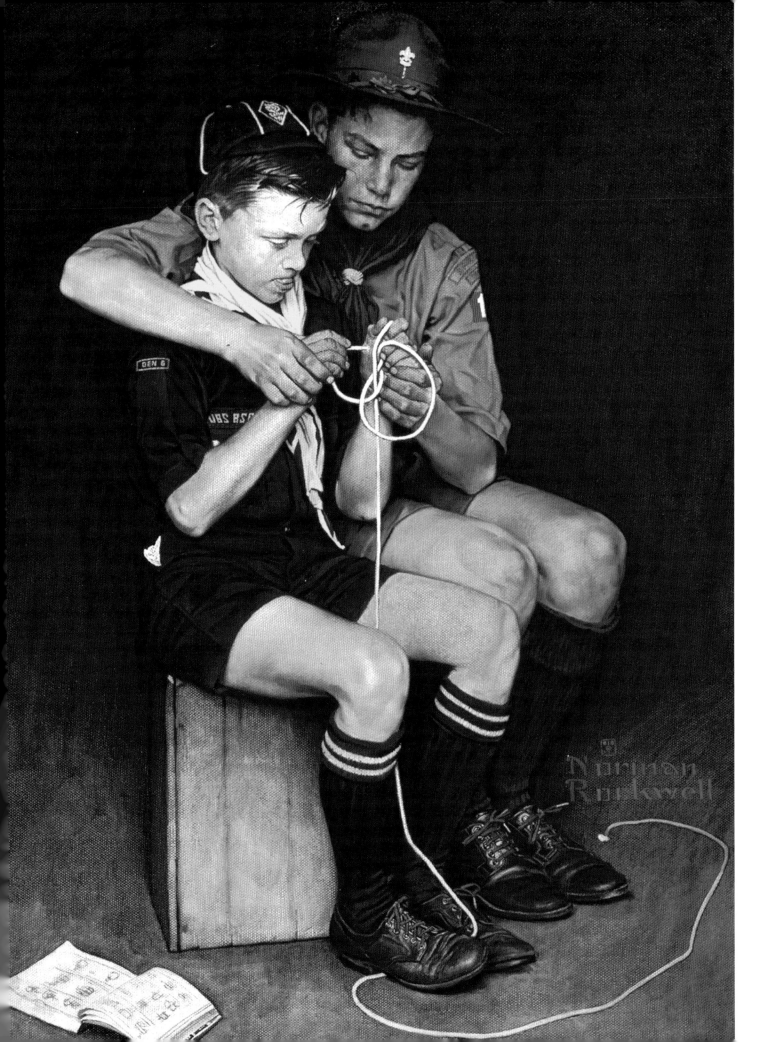

1946

A GUIDING HAND

To Rockwell, the hands in a drawing were second in importance only to the heads for conveying a message through a picture. "You can excite pity with them or you can make people laugh," Rockwell wrote in his book *How I Make a Picture* (1949). About *A Guiding Hand* shown here, he wrote: "These hands are … essential to the story. I tried to contrast the Cub Scout's younger and less skillful hands with the sunburned, skilled hands of the older Scout."

The Cub Scout in this painting is Rockwell's son Thomas, who is now an author and art historian.

1947

ALL TOGETHER

Again, Rockwell focuses on the helping hands to tell the story of Scout camaraderie in the high country. "Norman enjoyed doing this type of action picture," says Csatari. "And he knew that showing Scouts having adventures in the outdoors would attract more boys to Boy Scouting."

Notice the handwritten signature on this calendar painting and the one on *Men of Tomorrow* on the following page where it is scribed in all lowercase letters. Rockwell experimented with more than 20 different signature styles throughout his career, including "Norman Percevel Rockwell," as his name appeared in most of his *Boys' Life* illustrations. Norman disliked his middle name, and often abbreviated it to "Norman P. Rockwell" in the early part of his career. Most of his Scout calendars, however, carry the familiar hollow-letter style he created for himself (above right).

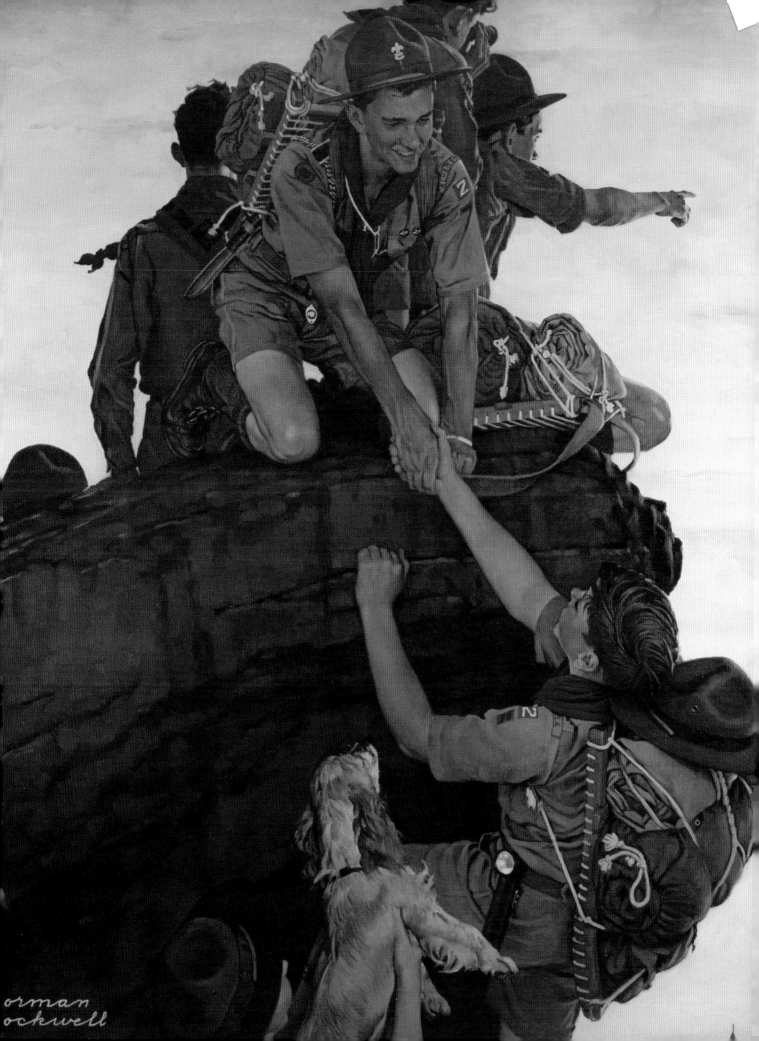

1948

MEN OF TOMORROW

Anyone who has earned his Canoeing merit badge knows that the Scout under the boat is making a solo canoe portage look easy. Of the 121 Merit Badges a Scout can earn as he progresses through the ranks, Canoeing is one of the oldest and most popular. No fewer than 2,754,919 boys have worn the badge from 1911 to 2007, according to BSA records. Whenever you see a man in a canoe carving a straight line on a lake (versus a zigzag one), it's likely he learned the J-stroke while earning his Canoeing merit badge at summer camp. Someday, the Cub Scout looking on outside of the painting will, too. That pinewood carving in his hands is a canoe, isn't it?

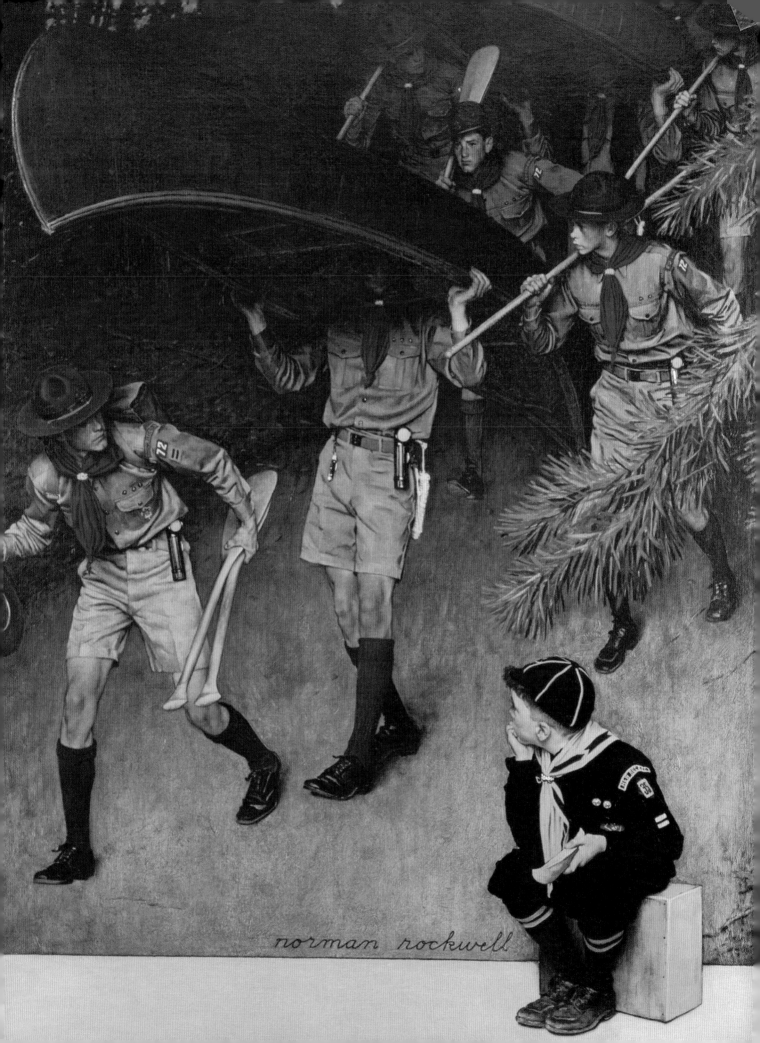

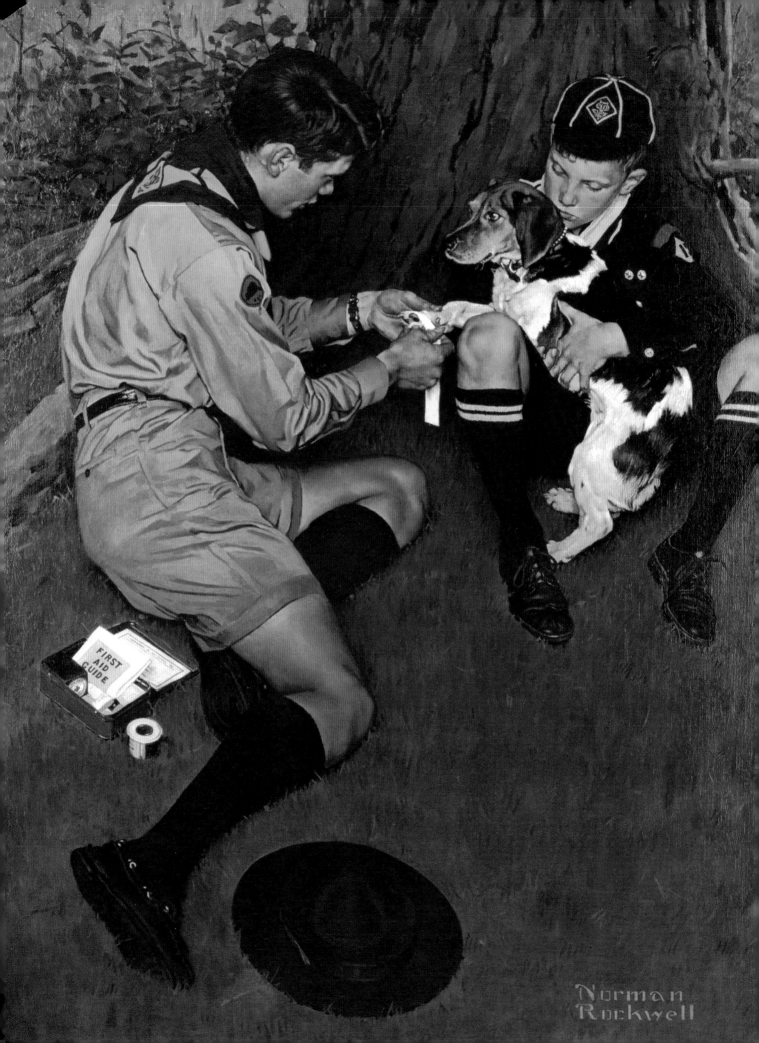

1949

FRIEND IN NEED

"The first job is to hit on a good idea," Rockwell said of the process for painting a cover or calendar. And he didn't hesitate from repeating one as shown in this, his third image depicting a Scout giving aid to a dog. While Rockwell was always bubbling with picture ideas, even he struggled to think of new concepts after decades of making Scout paintings. "The Boy Scouts are simply going to have to devise some new good deeds or Brown & Bigelow will be in a stew," he said in an article in *The New Yorker*.

1950
OUR HERITAGE

The angles created by the Cub Scout's left arm and the heads of the boys—even the bowed head of the horse—cause the viewer's eyes to move toward George Washington kneeling in prayer during the Valley Forge winter. This painting was made for the Second National Boy Scout Jamboree held at Valley Forge, Pennsylvania. The American history book in the Cub's hands further emphasizes the patriotic theme of this beautiful work.

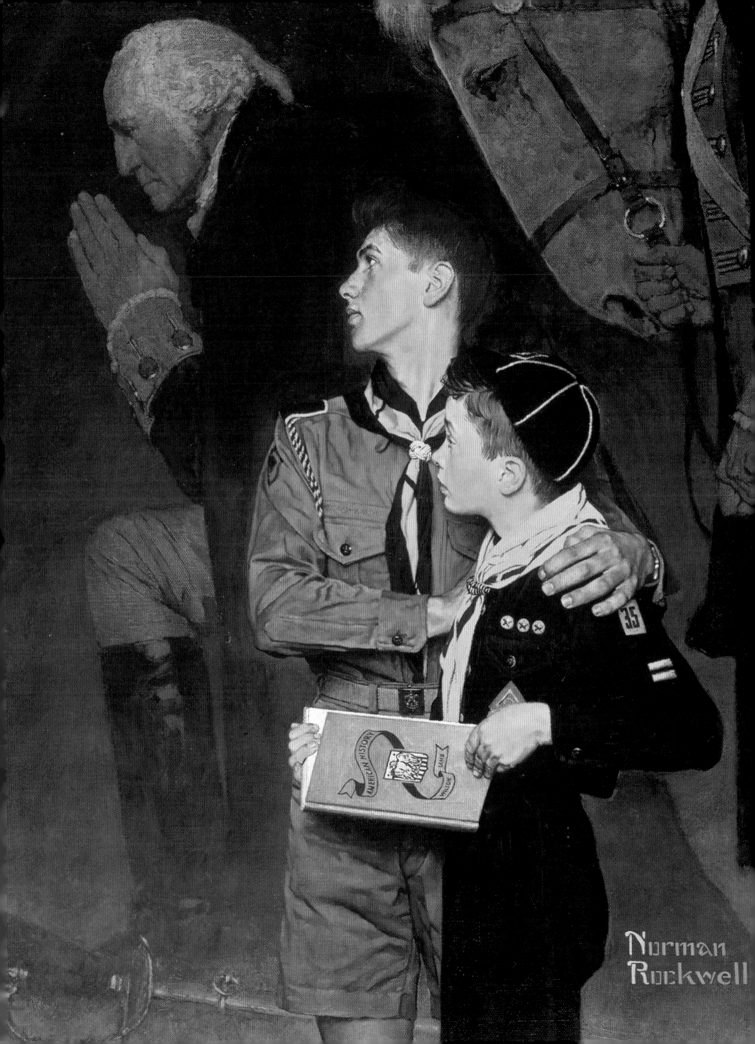

1951

FORWARD AMERICA

Over the years, the Boy Scout movement branched into Cub Scouting, Exploring, Air Scouting, and Sea Scouting as it grew in popularity. The officials of each program pressed to be represented on the BSA calendar, which created several challenges for Rockwell. First, how does one show such disparate organizations in action together on one canvas? The only answer was to line up the models like statues. The second challenge was time. It took a good deal longer to paint many figures in uniform than just one or two. And with Rockwell's extremely aggressive commission schedule, that caused the artist an anxiety he was all too familiar with. "A deadline is like a mean-tempered terrier," he wrote. "It won't leave you alone for a minute. You run and hide behind a tree and after a while, thinking you've escaped him, you step out and … rowf! He's got you by the heel."

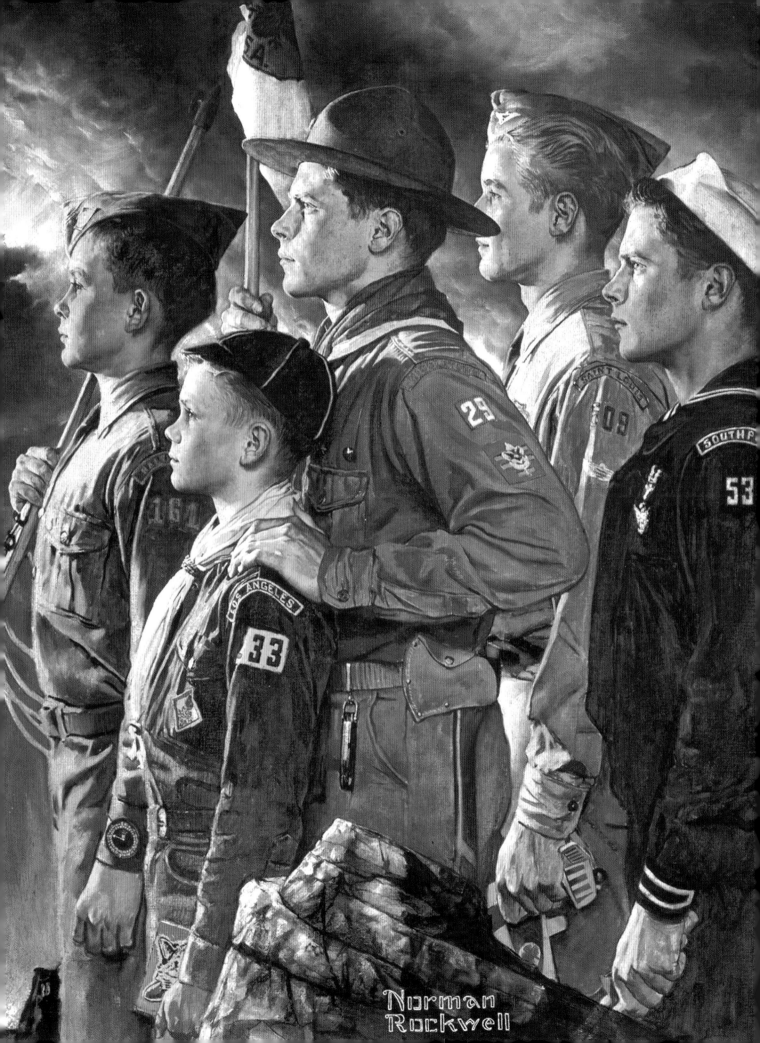

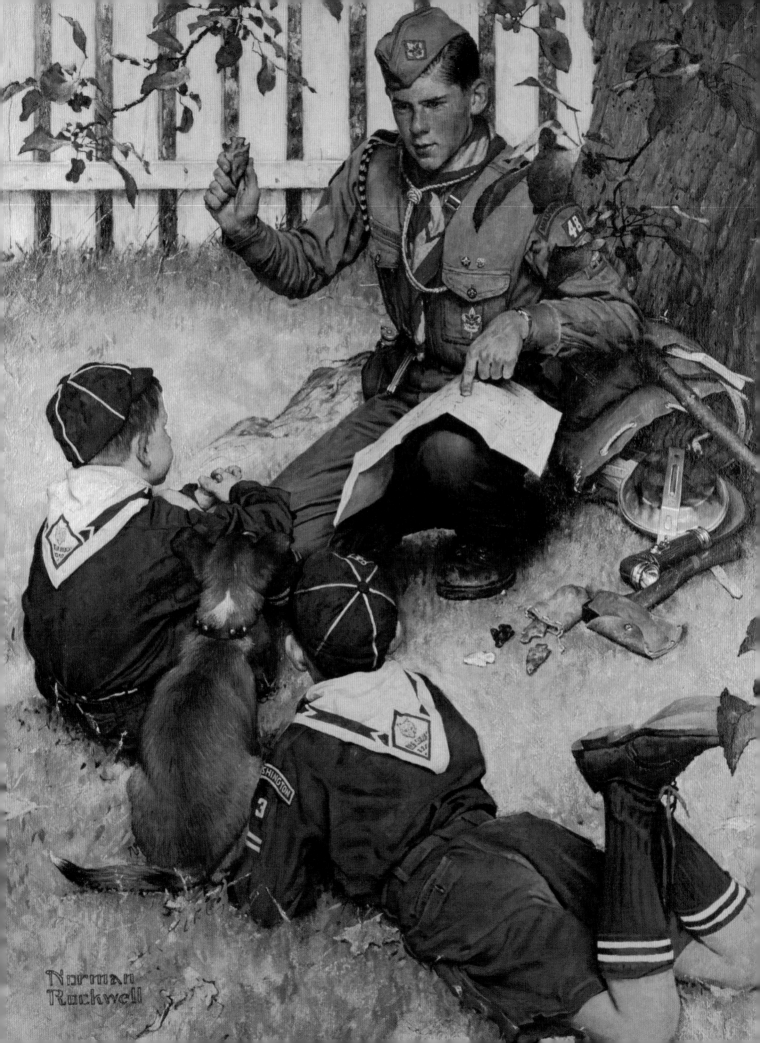

1952

THE ADVENTURE TRAIL

"A really good [painting] idea should contain an element of humor and pathos," Rockwell wrote. "[It] makes the reader want to smile and sigh at the same time." Rockwell knew the easiest way to elicit that emotional response from a viewer was to show a boy and his dog. This painting would not have been nearly as successful had he not included a four-legged pal in between the Cub Scouts listening attentively to the lesson as if the arrowhead in the Boy Scout's hand was a tempting dog biscuit.

1953

ON MY HONOR

Rockwell expresses the ideals of Scouting through the words of the Scout Oath over a background of the Liberty Bell, farmhouse, church steeple, and distant cityscape. This painting, in a slightly different form, appeared on the *Golden Anniversary Book of Scouting* published by Golden Press in 1959. This image presents a good opportunity for comparison of the changing styles of Scout uniforms over the years. Early Rockwell Scout drawings for *Boys' Life* show Scouts in choke-collar coats, knee breeches, and canvas leggings similar to the military uniforms worn by World War I "doughboys," as U.S. soldiers were called. In the 1920s, the military-style uniform was replaced by khaki shirts with neckerchiefs and shorts with knee socks. Until the late 40s, Scouts still wore the broad-brimmed campaign hat. But starting around the 1950s, overseas caps, similar to those worn by World War II GIs, came into fashion, despite the fact that they offered no protection from the sun. And long trousers joined the shorts as official pants.

1954

A SCOUT IS REVERENT

This painting marks the second time Rockwell used the title *A Scout is Reverent* from the Scout Law for a calendar illustration depicting Scouts in worship. While the Boy Scouts of America is non-sectarian, virtually every religion is represented in the organization, from Catholic and Protestant, Jewish, Buddhist, Islamist to the Armenian Church of America and Zoroastrian. The organization maintains that Scouts have some faith-based relationship with a higher power, a "duty to God," as presented in the Cub Scout Promise and Boy Scout Oath.

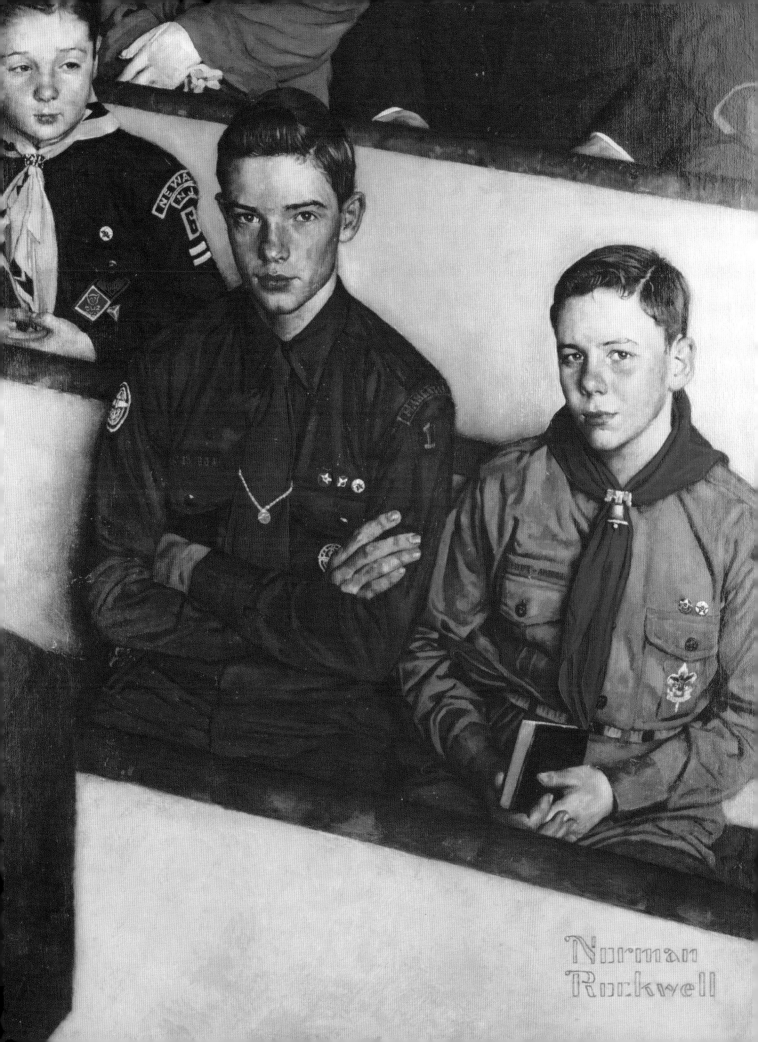

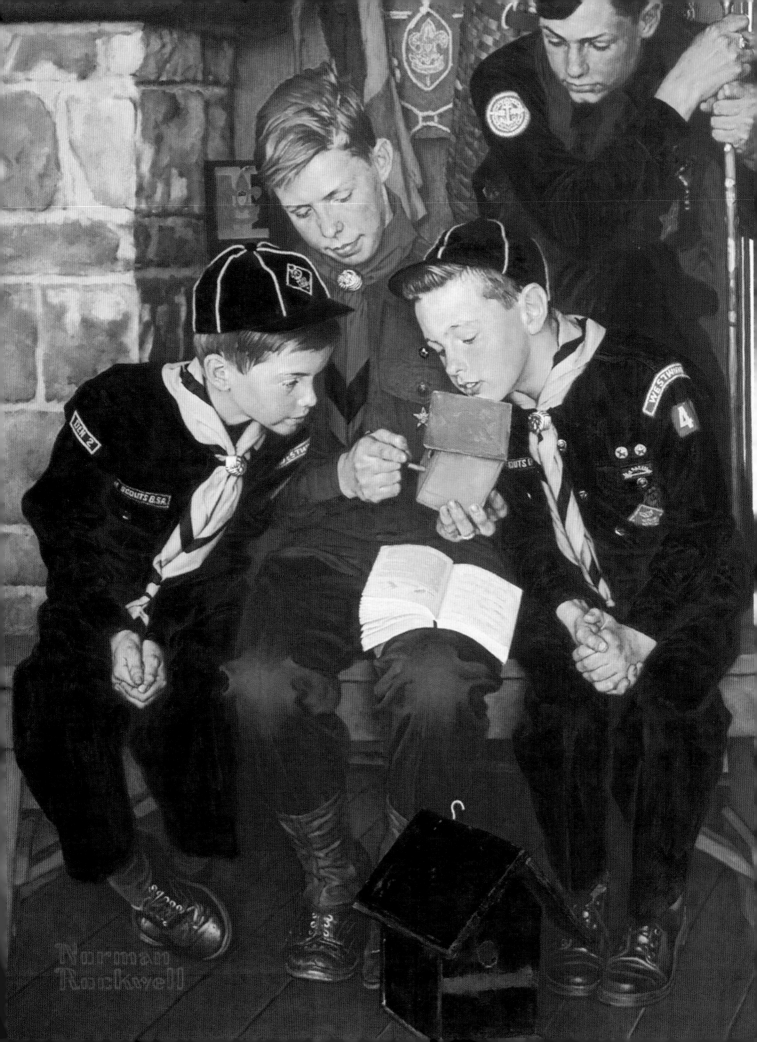

1955

THE RIGHT WAY

This painting of a Scout showing Cub Scouts how to build a birdhouse is an excellent example of pyramid composition, a technique Rockwell frequently used to structure his Scout paintings and *The Saturday Evening Post* covers. The Cubs form the sides of the triangle and the Scout's head the apex. Their eyes draw ours to the hands on the project.

During the mid 1950s Scouts built and placed 55,000 bird-nesting boxes such as this, planted 6.2 million trees, and arranged 41,000 nature displays as part of a national conservation initiative.

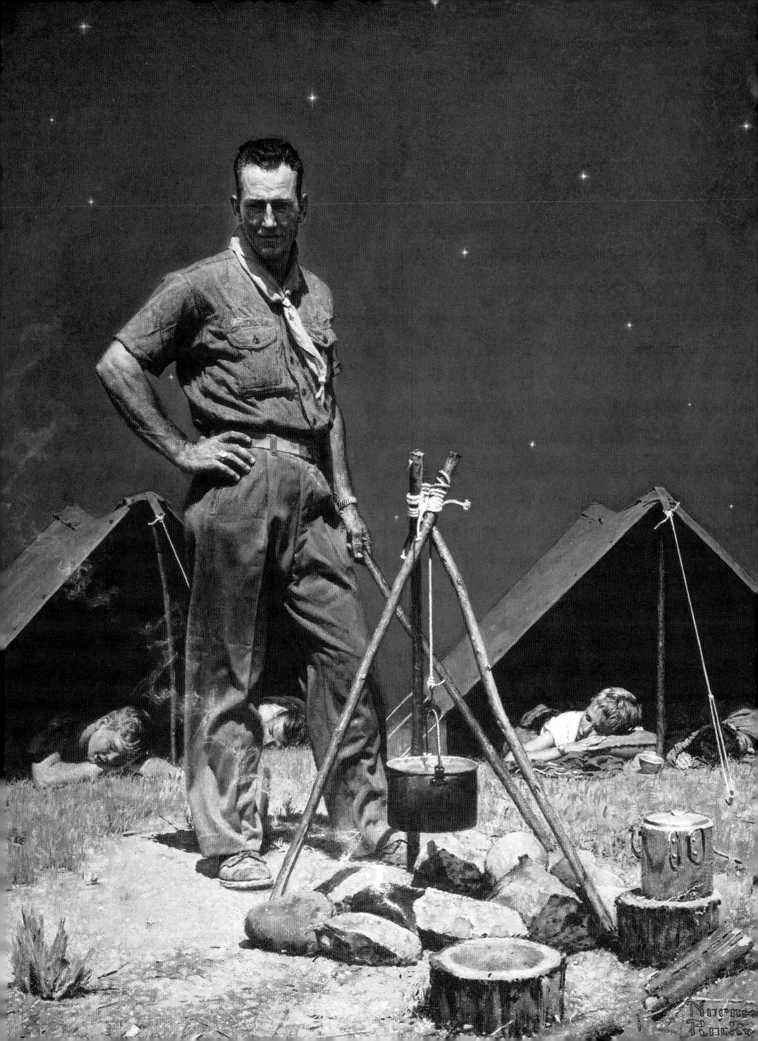

1956

THE SCOUTMASTER

All the diagonal lines of this illustration—the pup tents with their taut guy lines, the lashed poles of the tripod over the cook fire, the staff in the Scoutmaster's hand, even the angle of his neckerchief—guide our eyes to the focal point of the painting, the Scoutmaster. He's tending the dying fire late at night in the bright moonlight, watching over his troop. There's power in his stance, strength in his arms, contemplative wisdom in his demeanor. Rockwell chose cool blue colors to dominate the starry background and moonlit foreground while adding hints of red in the shadow areas inside the tents around the sleeping boys to convey warmth. All contribute to the pastoral mood of this powerful work of art.

1957

HIGH ADVENTURE

"One of the best ways to make an observer look at the point in a picture you wish him to see is to show the characters in your picture also looking at that point," wrote Rockwell. "The reader naturally will look there, too...." Here, the line of Explorer Scouts calling and pointing, directs the viewer to the center of interest—the mountain peak destination. The peak shown is a granite cliff called the Tooth of Time (elev. 9003 feet), in the Sangre de Cristo mountains near Cimmaron, New Mexico, home of the Philmont Scout Ranch. After attending the 1953 Boy Scout National Jamboree in Irvine, California, Rockwell visited the national high-adventure Scout reservation and shot pictures of the iconic peak, the surrounding landscape, and the pack burros used at the ranch. Philmont, the BSA's premier high adventure base is a 200-square-mile wilderness that hosts 15,000 campers a year. The land was donated to the Scouts by Oklahoma oilman Waite Phillips.

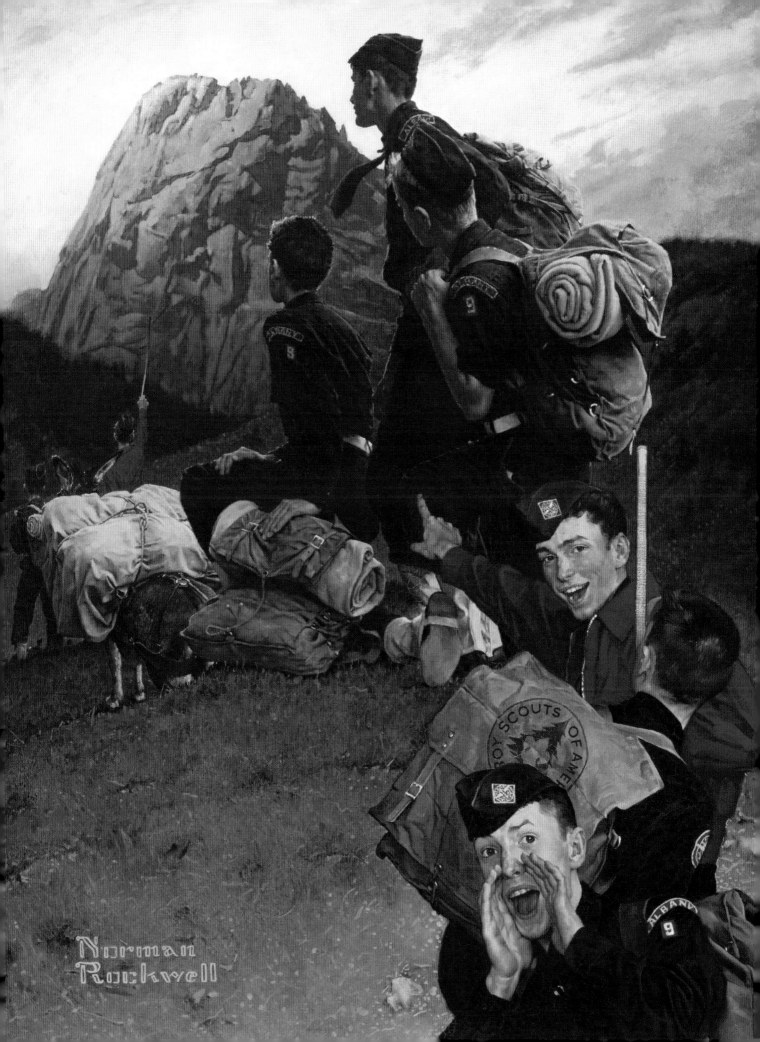

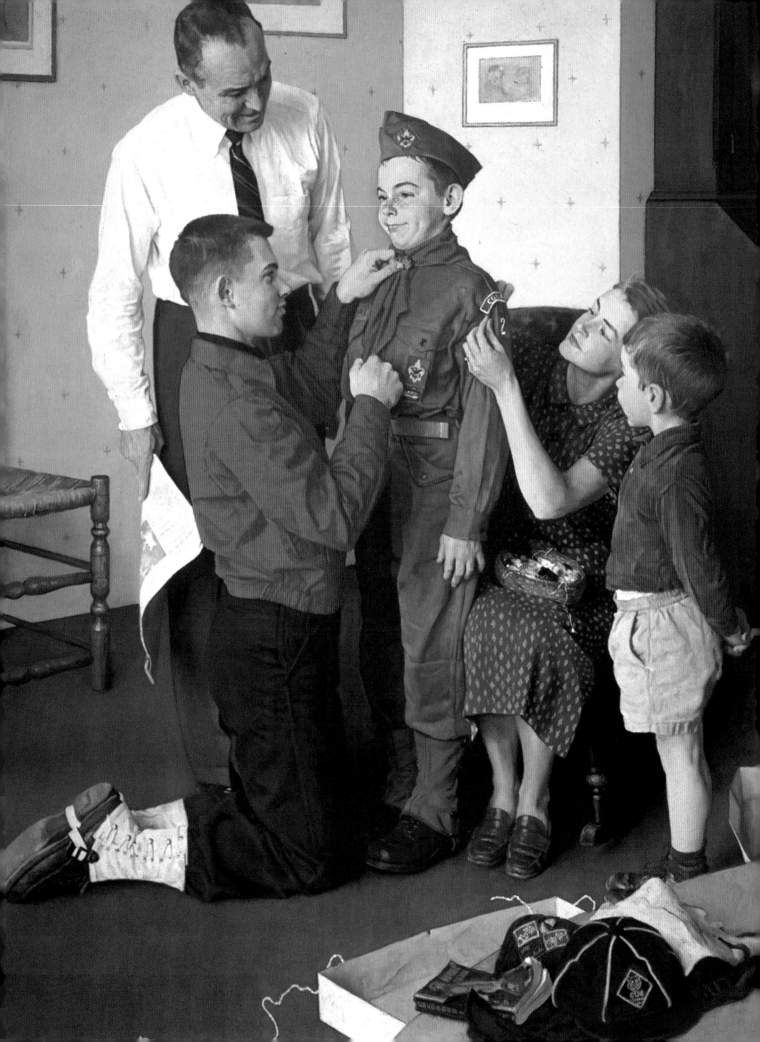

1958

MIGHTY PROUD

Rockwell depicts the proud day when middle brother crosses over from Cub Scouting to Boy Scouting as hinted by his old Cub uniform lying on the floor, mom sewing the council strip on the shoulder of a new Scout uniform fresh from the box, and older brother, an Explorer, adjusting his neckerchief slide. One expects that the Cub uniform might be boxed and saved for the youngest brother who's admiring the family ceremony.

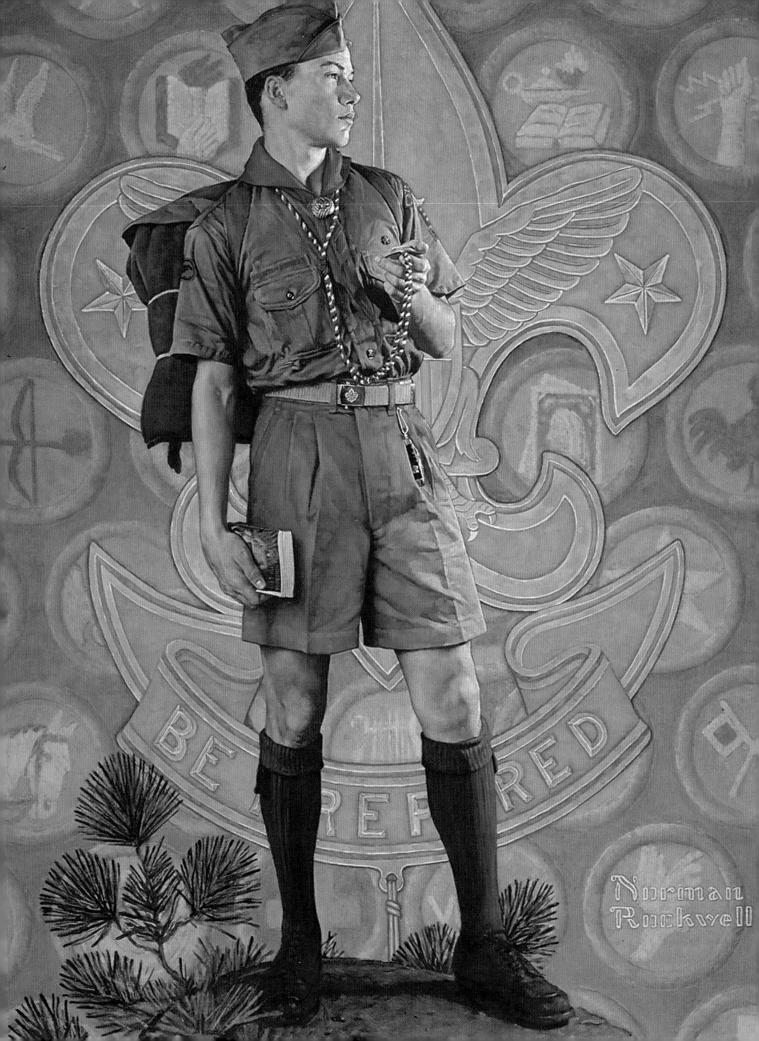

1959

TOMORROW'S LEADER

Look up a photo of Michelangelo's famous statue *David* and you'll recognize that Rockwell drew inspiration from the sculpture for the stance of the Boy Scout taking a compass bearing in this painting. The background here shows the badge of the First Class rank, complete with the Scout motto *Be Prepared*, and many of the merit badges that Scouts can earn. While a minimum of 21 are required for earning the Eagle Scout rank, there are 121 to choose from. Earning all 121 merit badges is extremely rare. Only one half of one percent of Scouts accomplish that feat.

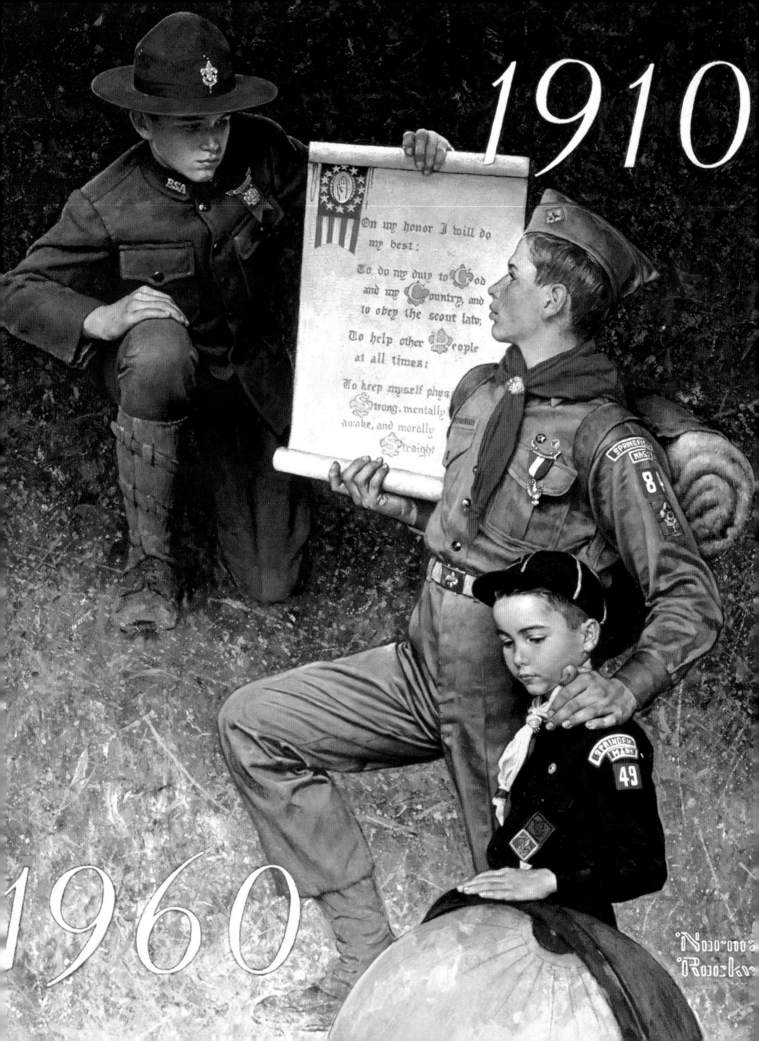

1960

EVER ONWARD (left)

Rockwell pairs his traditional style of realism with a modern abstract background reminiscent of a Jackson Pollock splatter painting in this calendar illustration marking the 50th anniversary of Scouting. For the new Scout handbook cover, Rockwell had agreed to do a scene of a patrol at camp, but he was so far behind on other commitments that he could not complete such an elaborate painting. Showing his angst over having to start on the Scout handbook painting, Rockwell wrote in his diary on June 16, 1959: "I don't like to let on to be smarter than the next man but I know one thing: there won't be any deadlines in heaven."

BOY SCOUT HANDBOOK COVER (below)

Rather than give up the handbook job, Norman decided to paint a single figure of a Scout hiking and waving. Another illustrator later drew the background illustrations.

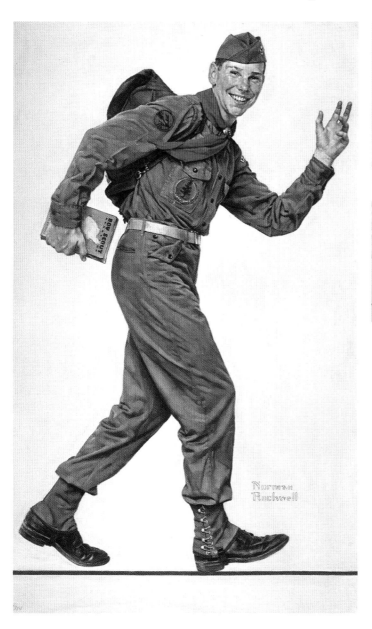

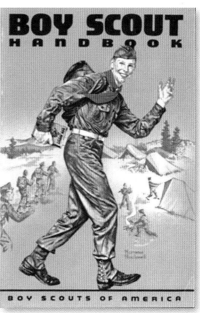

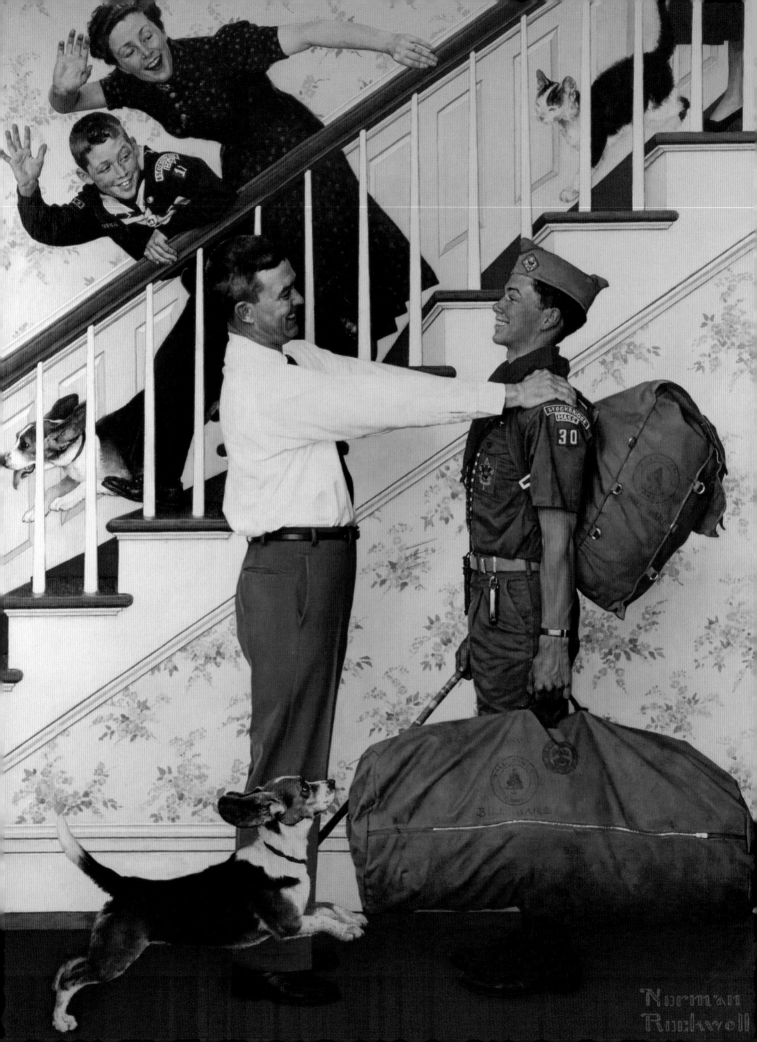

1961

HOMECOMING

Rockwell juxtaposes the horizontal lines in the stairsteps and dad's arms against the vertical posts and the angular railing on the staircase to create tension and reinforce the notion of the family—dogs and cat, included—rushing to welcome brother home from Scout camp. Doesn't mom look happy to see her eldest son? Wait 'til she gets a load of the laundry in his duffel.

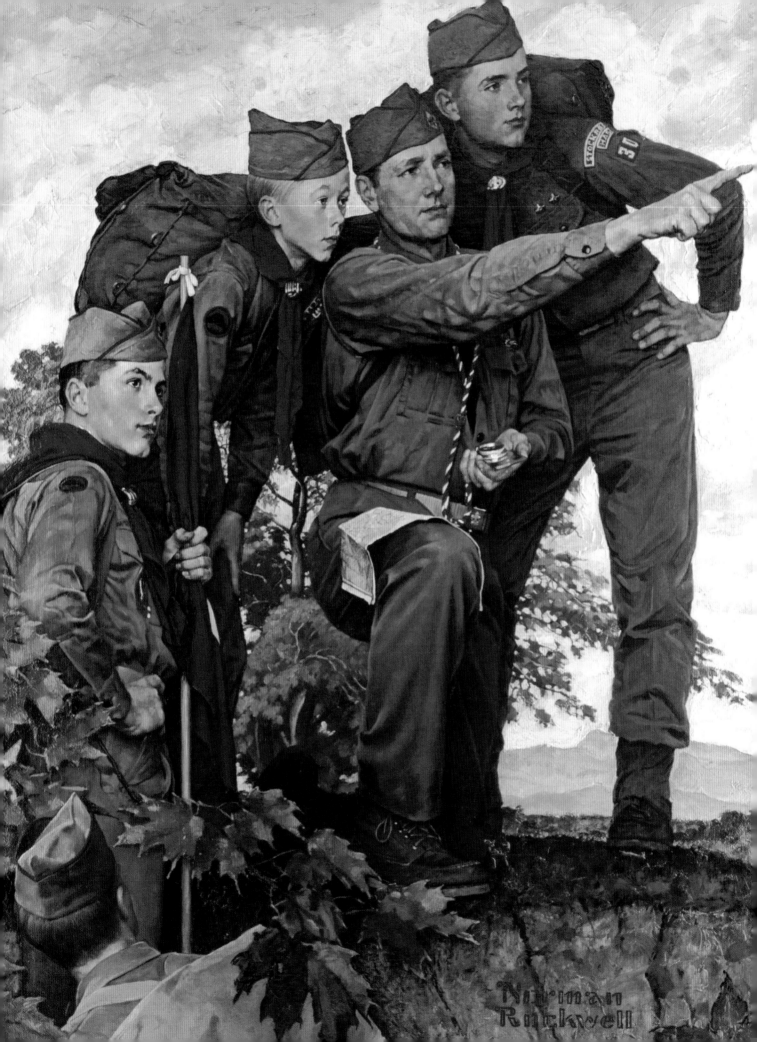

1962

POINTING THE WAY

No one who has ever been on a campout with a troop of 11- to 16-year-old boys will recognize the well-groomed lads here with their caps placed perfectly and their khakis spotless and wrinkle-free. Even Scouts in the 50s and 60s were magnets for mud and grime, not to mention "sleeping bag head." But Rockwell allowed himself to compromise reality for the higher purpose of representing the organization and its members in the most positive light—especially since the calendar image would need to appeal daily for an entire year! What's more, each calendar painting needed the stamp of approval of the Boy Scouts of America executives who demanded perfection. The uniform must be immaculate, regardless of the mud, sweat, and tears it might endure on the body of a Tenderfoot in action. The badges, insignia, and equipment must be meticulously and accurately portrayed, and the models themselves should be handsome, wholesome, "freshly complexioned and well-scrubbed…the pride and joy of every mother."

1963

A GOOD SIGN ALL OVER THE WORLD

In this lively painting dedicated to the world brotherhood of Scouting, Rockwell depicts a Scottish Scout teaching an American boy the Highland Fling. Scouts from India and Indonesia keep the beat for the bagpiper while Scouts from other nations climb the hill at bottom right to see what is going on. The universal three-fingered Scout sign is shown in the background over an outline of the world. This painting marks the 11th World Jamboree attended by 12,000 Scouts in Marathon, Greece. It is the second of three paintings Rockwell made on the theme of the world Scouting. The first, 1933's *An Army of Friendship* (see p.26) celebrates the Fourth Scout World Jamboree held in Hungary. The third, *Breakthrough for Freedom* (see p.91), was made for the 12th World Jamboree in Idaho in 1967.

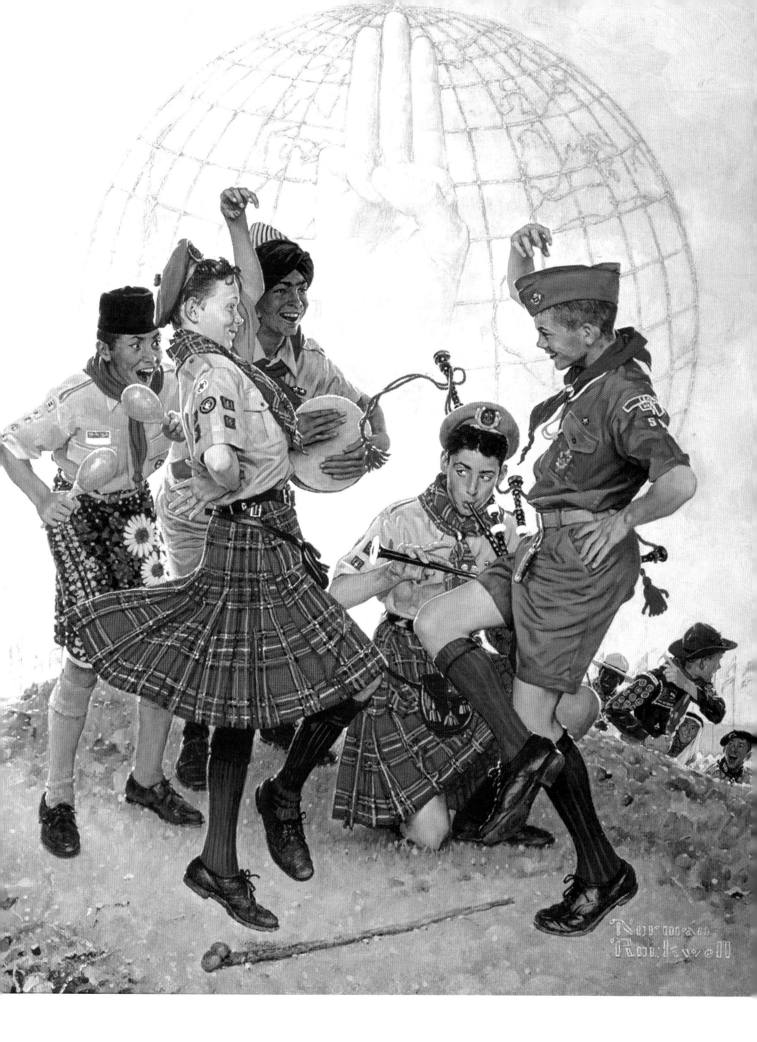

1964

TO KEEP MYSELF PHYSICALLY STRONG

When he was a boy Norman longed to be strong and strapping like his older brother Jarvis, the best athlete in the school, who could "jump over three orange crates," so it is not surprising that the artist came up with a scene such as this to illustrate this part of the Boy Scout Oath. At age 10, he started a program of exercises to strengthen himself. Every morning, young Norman would check himself in a mirror to look for improvement. "It did no good," he said. "I was a skinny kid with stringy arms and chicken legs…a bean pole without the beans."

Getting the Painting Right (below)

This photograph shows Rockwell adding some final touches to the painting *To Keep Myself Physically Strong* while his models pose in front of his easel. In the early days, Rockwell worked exclusively from live models who would pose in this way. However, for most of his career, Rockwell worked primarily from photographs, which saved a lot of wear and tear on his models and himself. On occasion, as shown here, he would bring models back to pose live, usually to check color values or to reposition a hand or alter the angle of a head.

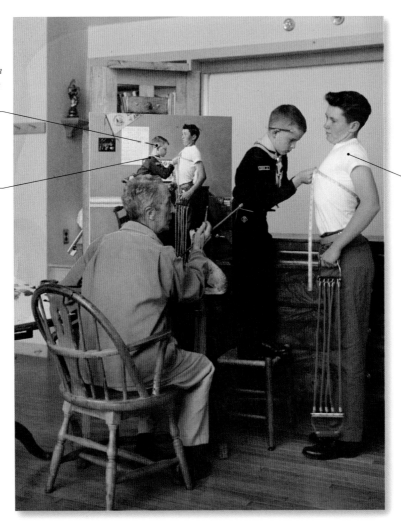

Rockwell liked to paint heads about five inches high on his canvas because that allowed him to paint features and expressions in complete detail.

"The Boy Scouts are sticklers for details," Rockwell said. "The neckerchief must be exactly the right color…the insignia must be correct and clearly seen."

Selecting the right model was critical to Rockwell's success. Once he found the perfect one, he had to coax him to strike the right pose. "You must be a sort of movie director," he said.

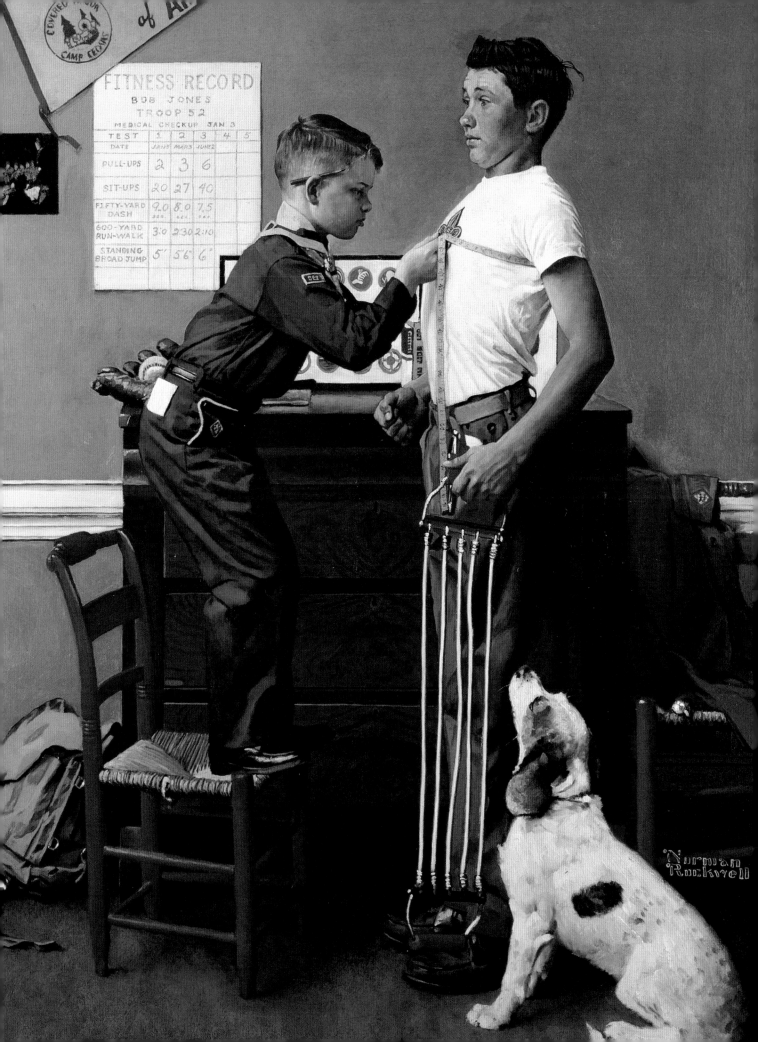

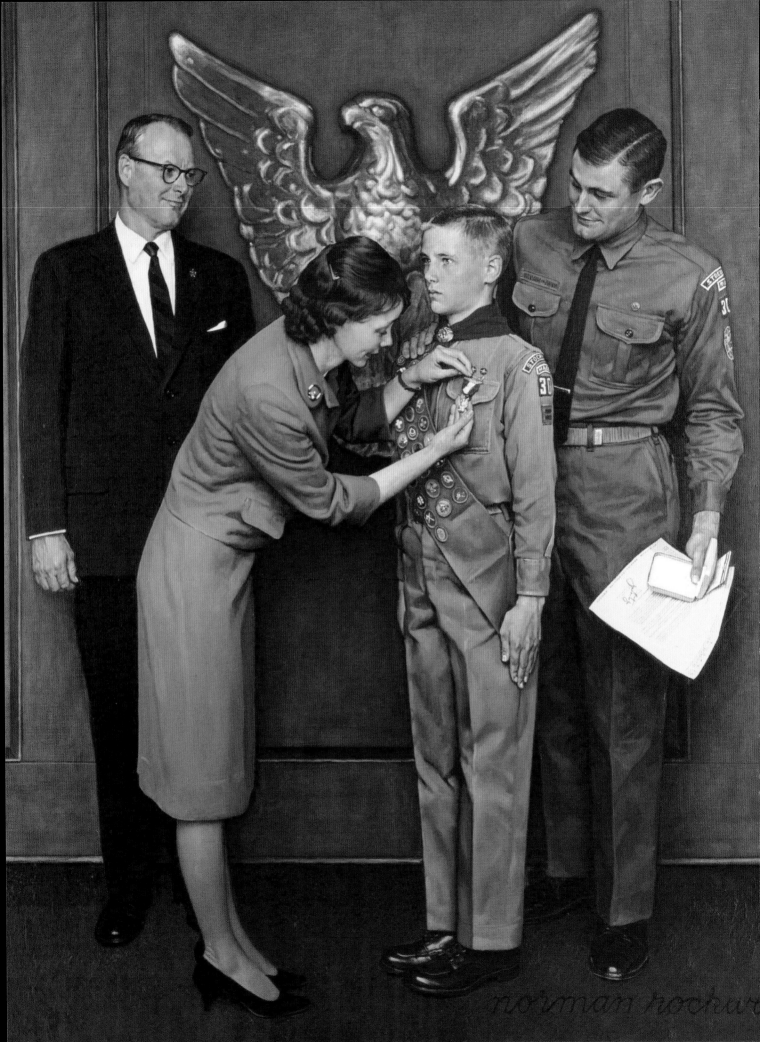

1965

A GREAT MOMENT

The trail to Eagle, Scouting's highest rank, culminates in the Eagle Scout Court of Honor, in which it is traditional for a mother to pin the award on her son's uniform. To reach Eagle, a Scout must advance from Tenderfoot through the Life Scout rank, earn a total of 21 Merit Badges, serve in a leadership position within the troop, and plan and execute a significant service project that benefits his community. It's not easy to achieve. In fact, only five percent of all Scouts reach Scouting's pinnacle.

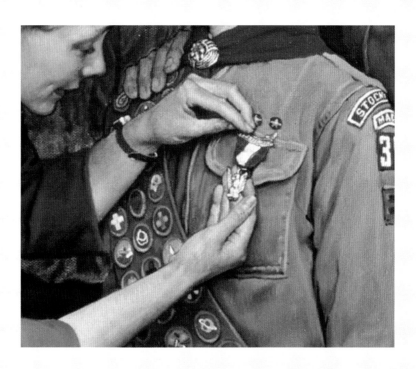

1966

GROWTH OF A LEADER

In this painting, Rockwell illustrates the Scout organization's hope that Cub Scouts and Boy Scouts will grow into the Explorer program, depicted by the young man in the blue–green uniform, and eventually serve as Scout leaders in adulthood.

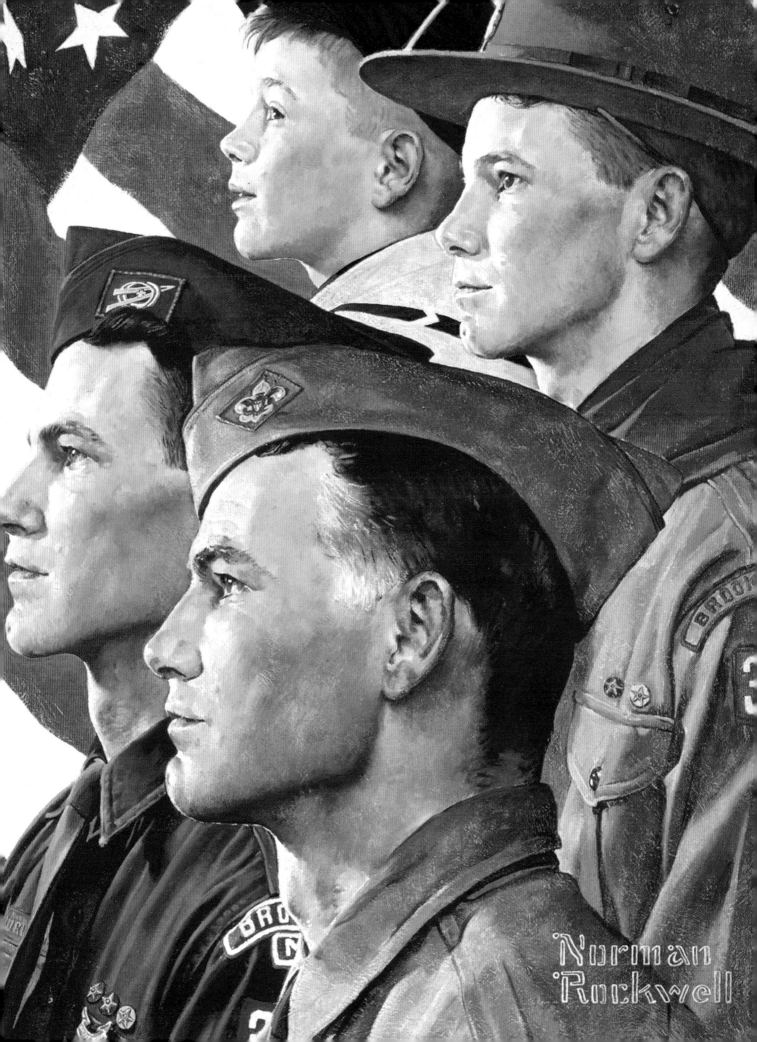

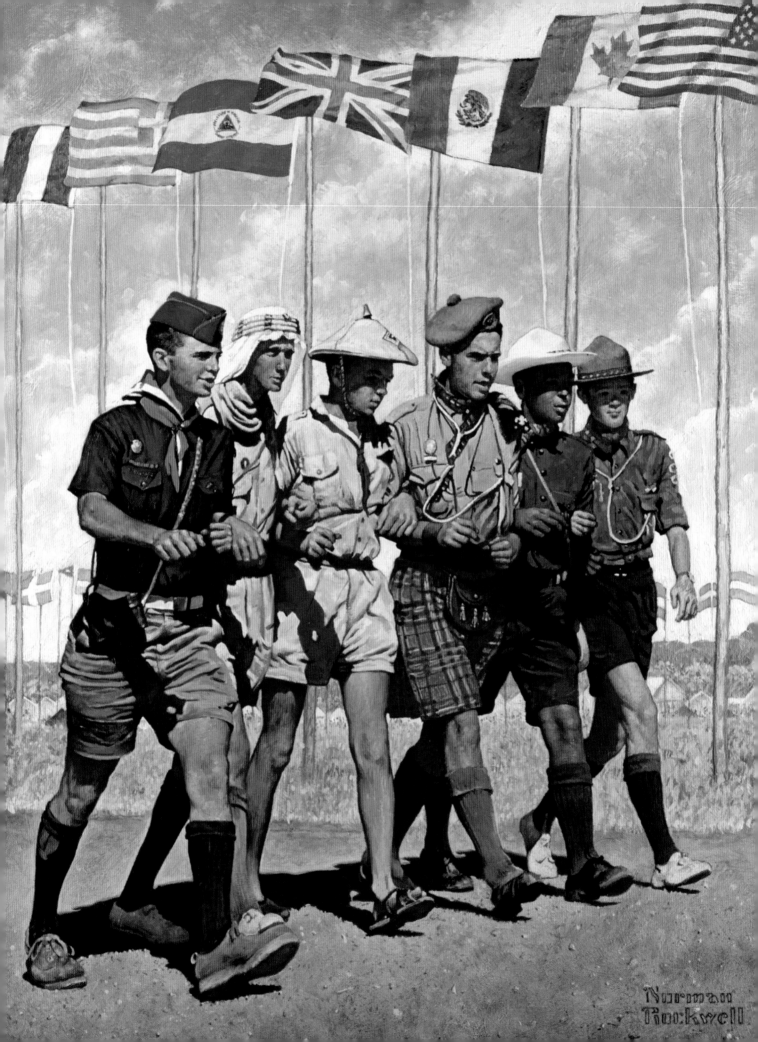

1967

BREAKTHROUGH FOR FREEDOM

After producing several color rough sketches for a calendar promoting the 1967 World Jamboree, Rockwell scrapped his original ideas and drew inspiration from a photograph of Scouts from different lands striding arm in arm, which was taken at the 1963 World Jamboree in Greece. Norman simply changed the uniforms and country flags to reflect a sampling of the various regions of the world. The Scouts he illustrated appear to be, from left, an American Explorer, Arab Scout possibly from Kuwait, Filipino Scout, Scottish Scout, African Scout possibly from Kenya and a Japanese Scout. In addition to the U.S. flag on the poles in the background are (from left) Nigeria, Greece, Nicaragua, the United Kingdom, Mexico, and Canada. More than 12,000 campers from 105 countries attended the 12th World Jamboree, held at Farragut State Park in the Rocky Mountains of Idaho. The event, themed "For Friendship," featured arena shows, adventure trails, a skill-o-rama, Western Rodeo, a reconstruction of Baden-Powell's Brownsea Island Camp, and visits from Lady Baden-Powell and U.S. Vice President Hubert Humphrey.

1968

SCOUTING IS OUTING

Rockwell understood the purpose of his calendars to advertise the values of Scouting and call more boys into its ranks. Here he tells the story of Troop 52 leaving for an overnight hike. But you'll notice a more subtle message if you follow the hand-wave of the Scout under the sign on the building. He's calling to the kid in the window, who seems to wish he was joining them. Even the boy's dog appears envious of his four-legged pal at the bottom of the frame sprinting up the street.

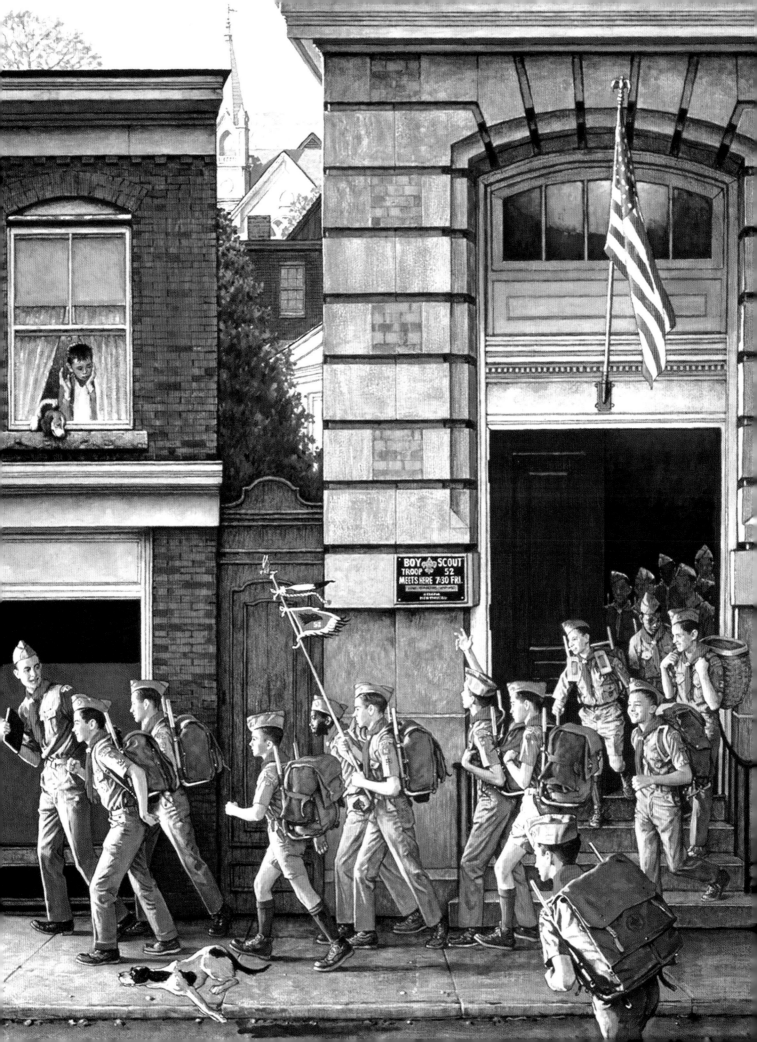

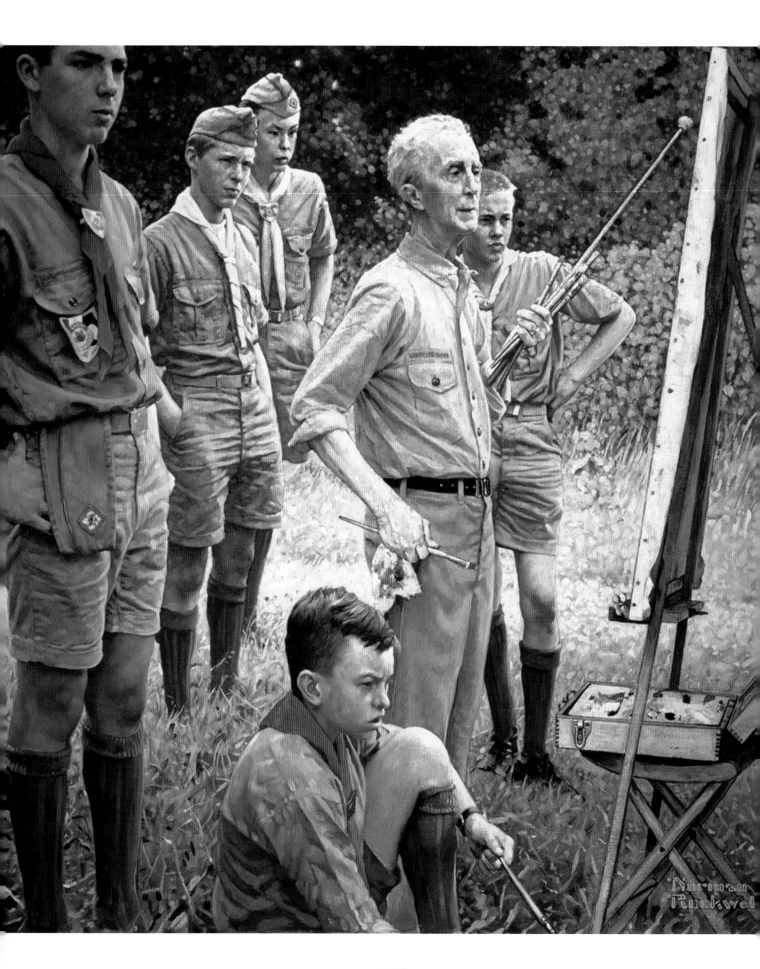

1969

BEYOND THE EASEL

Brown & Bigelow and Boy Scouts executives implored Norman to include himself in the 1969 calendar painting in honor of his 75th birthday. Rockwell reluctantly agreed. Here the Scouts contemplate the scene that Rockwell is rendering on canvas. The pole that Norman is holding in his left hand along with the brushes is called a moll stick. An artist rests the round end on the canvas and uses the stick as a brace to steady the hand holding the brush.

Some observers refer to *Beyond the Easel* as "the one-legged Scout painting." Look at the boy behind Rockwell in the far background. Is his left leg missing or is it obscured by the Scout in front of him?

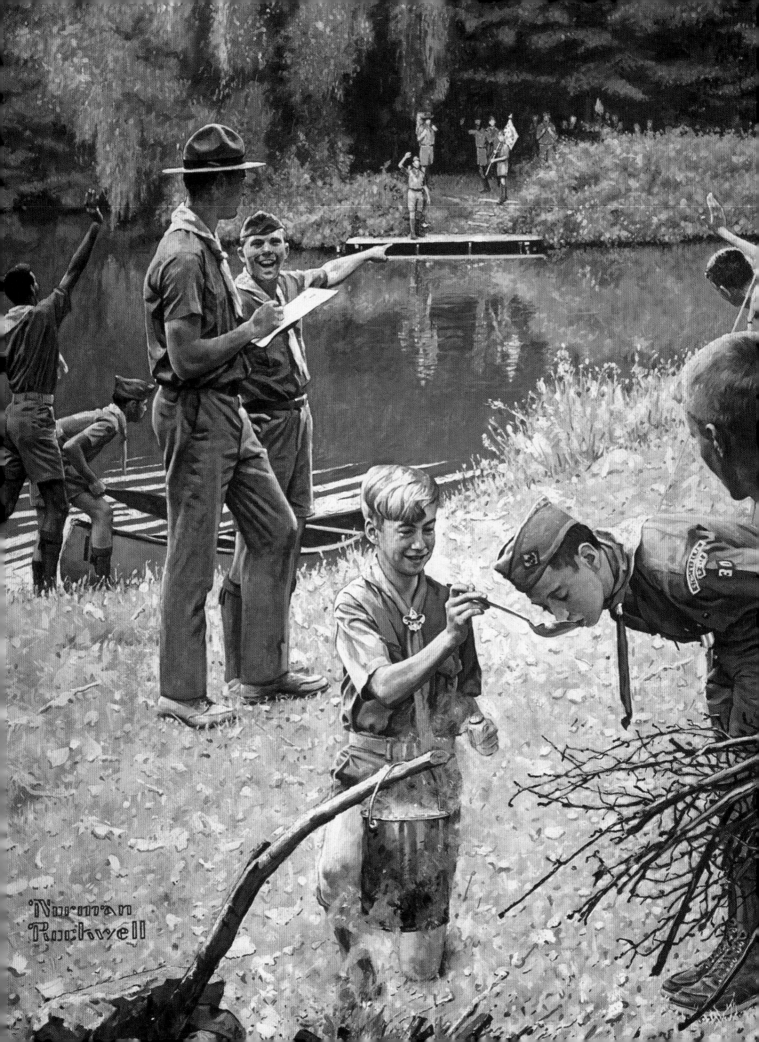

1970

COME AND GET IT!

Camping is synonymous with cooking over an open fire—or, these days, typically a more efficient white-gas-fueled backpacking stove. Regardless of the heat source, the quality of the meal is in the hands of the cook, here offering a taste to a buddy. *More pepper for the chili?* Fortunately, hiking, canoeing, and hours at playing capture the flag can work up a boy's appetite something fierce, which has the uncanny ability to make his taste buds less particular.

1971
AMERICA'S MANPOWER BEGINS
WITH BOYPOWER

For the 1971 calendar, the BSA wanted Norman to represent every level of the organization, from Cub Scout to Explorer, volunteer and local professional Scout leaders and right on up to the National President and Chief Scout Executive. The only way to get nine characters in one frame to his liking, Rockwell figured, was this way, "by lining them up like sardines." Rockwell preferred to paint heads about five inches in size and this composition allowed for that.

Before the photo shoot, Rockwell asked his art director on the project, Joseph Csatari, to send him some model cards from the New York City modeling agencies so he could select a woman to pose as the Den Mother. Csatari did as instructed, but secretively included a headshot of his wife Susan in the mix of model shots he mailed to Rockwell. The artist unwittingly chose Csatari's wife to play the Den Mother, but didn't learn the truth until they were introduced at the photo shoot.

The man at the upper left is BSA president at the time Irving Feist, and next to him in the campaign hat Chief Scout Executive Alden Barber. Csatari believes Norman may have used an old photograph of himself as reference for the Sea Scouting volunteer leader whose face is obscured. Rockwell, himself, was a former Navy sailor.

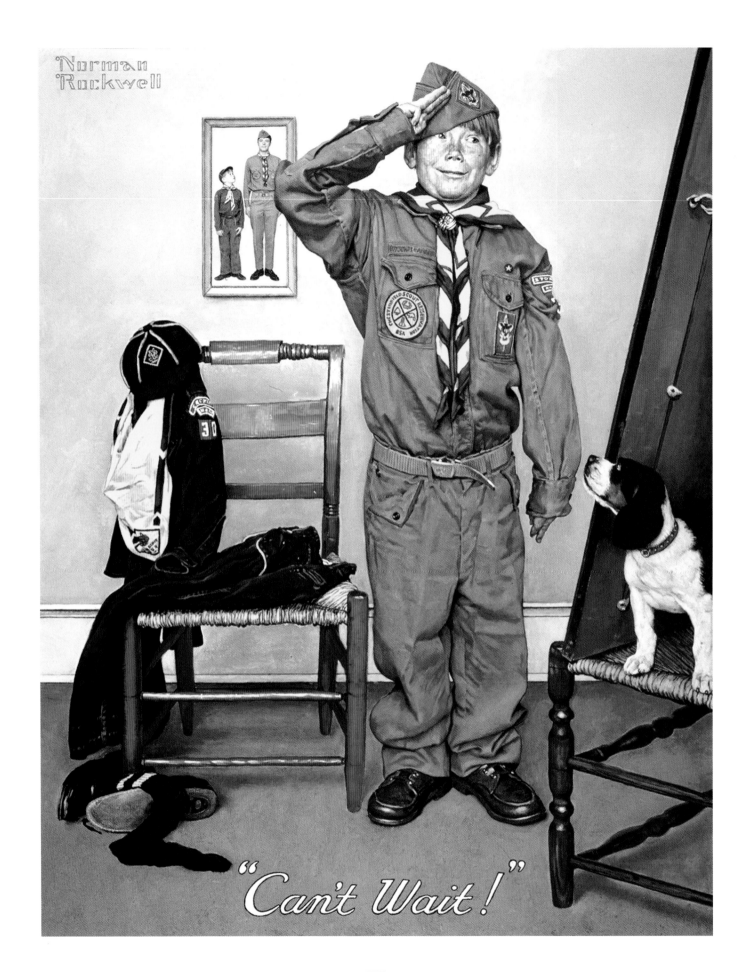

"Can't Wait!"

1972

CAN'T WAIT

Sometimes a good idea walks right in the door. Csatari and Rockwell were posing Boy Scouts playing band instruments for the '72 calendar photography session when in walked little Hank Bergmans, one of Norman's favorite young models, wearing a Scout uniform that was three sizes too big. "There's your next calendar, Norman," Csatari said. A Cub Scout tries on big brother's Boy Scout uniform; he "can't wait" to become a Scout. The men laughed at the scene, but the idea was dropped—that is, until the next day when Rockwell called Csatari at home: "I'm nuts about this *Can't Wait* picture. Do you think you can sell the Scouts on it?" Rockwell was concerned that the Boy Scouts of America executives might not appreciate the humor in the idea but he felt that the appeal was strong enough to give it a try. The BSA loved the idea, and agreed to abandon the original theme. *Can't Wait* became one of the most popular Scout calendars, no doubt because it tapped into the Rockwellean humor that Americans so loved. Rockwell included the note below when he shipped the finished painting to Csatari, his art director, at the Boy Scout Headquarters.

NORMAN ROCKWELL
STOCKBRIDGE
MASSACHUSETTS

Dear Joe,—
Here it is!
Hope you like how
I rendered your
wonderful idea

Cordially

Norman

1973

FROM CONCORD TO TRANQUILITY

The title of this painting recalls the location of the start of the American Revolution at Concord, Massachusetts, and the astronauts' landing site on the moon's Sea of Tranquility. Csatari's original color rough, which Rockwell used to develop this painting, contained a technical error which no one caught until Rockwell's final oil painting arrived at Scout offices for review. Someone noticed that the Explorer, dressed in a blazer and tie (at the time not considered a uniform) was giving a hand-to-head salute, which was incorrect. Sheepishly, Csatari returned to Stockbridge to deliver the news to Rockwell, along with some new photographs of the hand positioned properly over the heart. "I remember when we had the painting back on his easel, Norman spat on his palette and mixed in some white casein paint," recalls Csatari. "'This will make it dry faster,' he told me." Quickly, Rockwell whited out the saluting hand and sketched in the rest of the astronaut's American flag patch. Then he sketched in the fingers of the right hand in position on the blazer. "In 30 minutes, he was finished painting. I remember thinking that would have taken me *hours*."

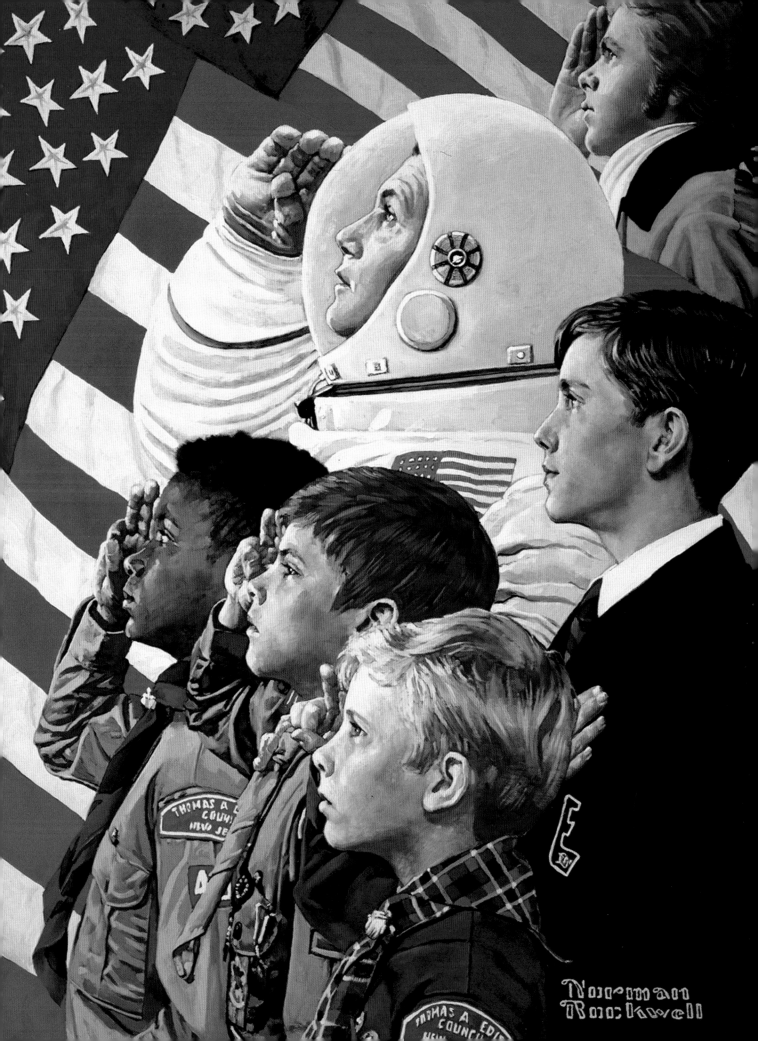

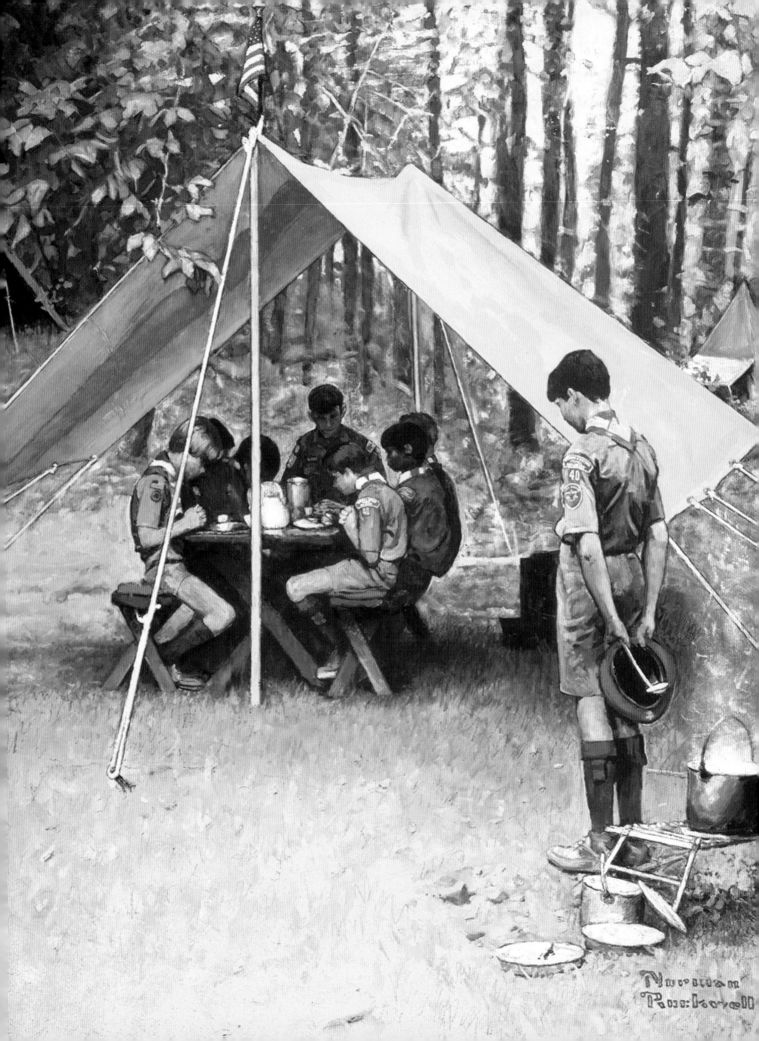

1974

WE THANK THEE, O' LORD (left)

The third Rockwell Scout painting to portray the theme of reverence shows a troop at camp in prayer before a meal. In all likelihood, the boys are saying the Philmont Grace. Scouts and former Scouts will recall the Philmont Scout Ranch prayer from countless mealtimes at summer camp mess halls and troop campouts:

For food, for raiment
For life, for opportunity
For friendship and fellowship
We thank thee, O' Lord

Getting the Painting Right (below)

In this photograph below Rockwell and Csatari look over a layout as the Scout models sit in position under a dining fly. From the reference photos taken that day in the New Jersey woods, Rockwell produced a detailed charcoal drawing (left) and a color rough sketch (right). From concept to final oil painting, the entire process took Rockwell three weeks to over a month depending upon the number of figures in the illustration.

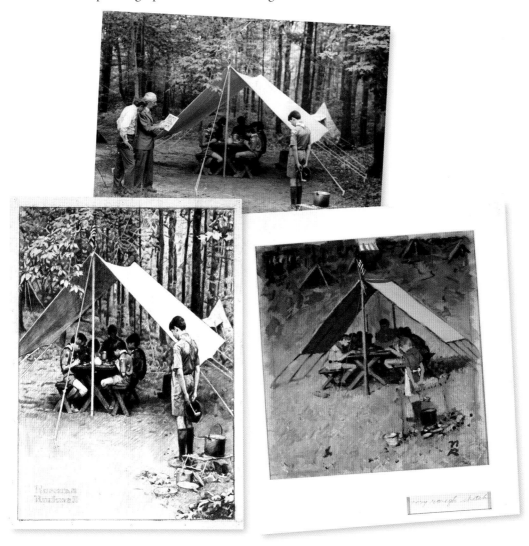

1975

SO MUCH CONCERN (right)

This calendar illustration of Scouts improving the environment by planting evergreen saplings reflects the Boy Scouts of America's long history of conservation initiatives. For this painting, Scout executives also requested a Scout with foot brace and crutch be included in the composition to indicate that the Scout program is available to all boys regardless of physical ability. An interesting historical note: In 1978, *So Much Concern* was one of seven Rockwell's stolen from an art gallery near Minneapolis, Minnesota. This painting and Rockwell's final Scout work, *The Spirit of 1976*, remained missing until 2001 when the FBI recovered them from a farmhouse in Rio de Janeiro, Brazil, where they were being hidden.

Getting the Painting Right (below)

Rockwell (left) adjusts a Scout's red beret while showing the layout for the scene, which was shot in a nature preserve behind the BSA National Council office when it was located in North Brunswick, New Jersey; BSA headquarters is now based in Irving, Texas. That's art director Csatari in the checkered trousers (below) preparing the hole for the pine seedling.

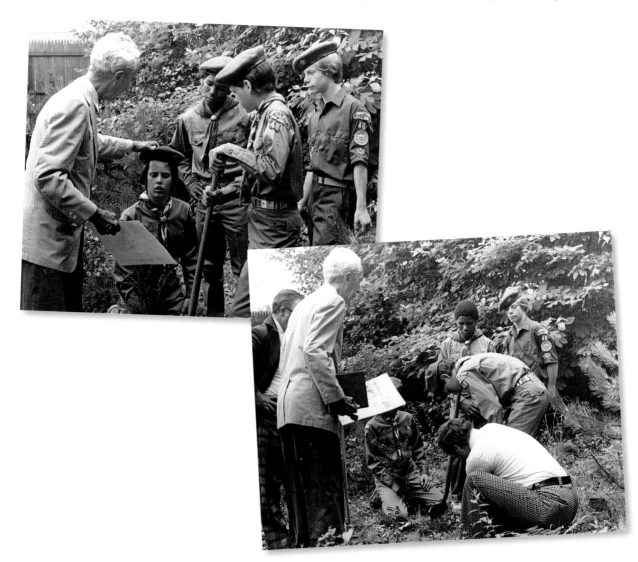

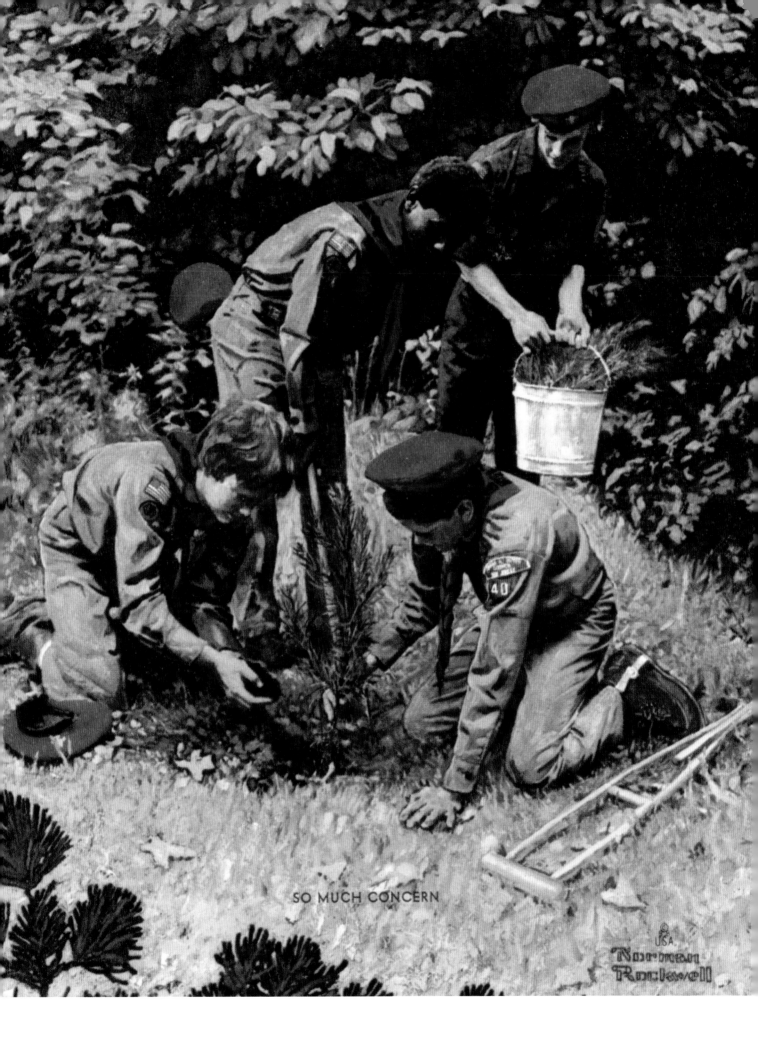

SO MUCH CONCERN

Norman Rockwell

1976

THE SPIRIT OF 1976

Fittingly, Norman Rockwell's last Boy Scouts of America calendar painting celebrated the nation's 200th birthday. For the bicentennial work, Rockwell recreated Archibald M. Williard's famous painting *Spirit of '76* by replacing his Revolutionary War patriots with Scouts playing the fife and drums. The completed oil painting has an impressionism quality about it; it looks as if Rockwell was attempting to "loosen up," that is, use larger brushstrokes of paint. In all probability, Rockwell's advanced age had affected his sense of color and the steadiness of his hand limiting his ability to paint close detail. But even at age 81, Rockwell did not deviate from his meticulous process, which we see a glimpse of in the images below.

Getting the Painting Right (below)

These are photo outtakes from the modeling session which took place in Rockwell's Stockbridge studio. One indicates Rockwell's choice with a note to Csatari. Below right is the original proposed layout that Norman sketched.

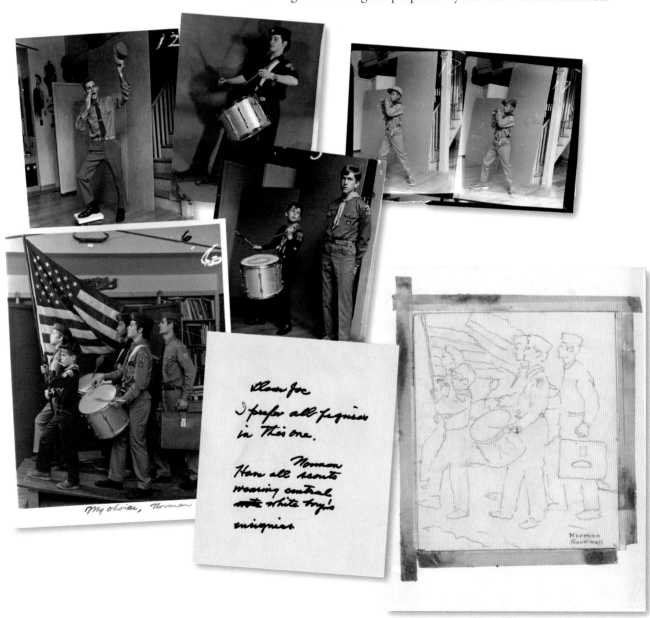

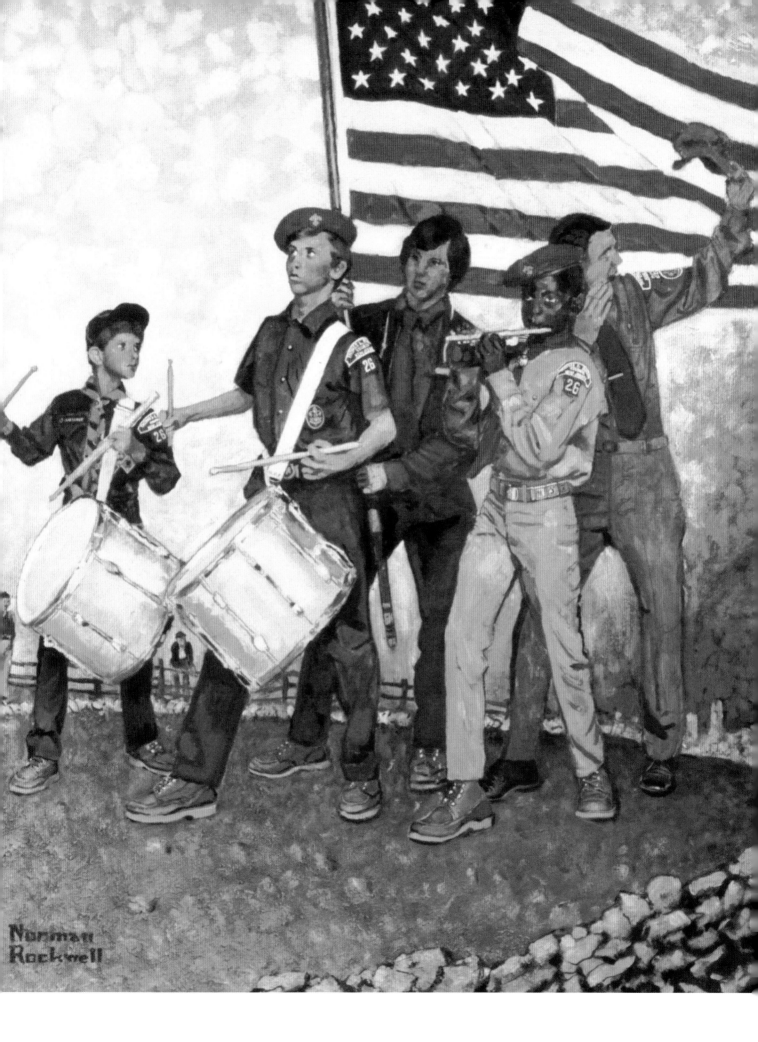

THE JOSEPH CSATARI
PAINTINGS

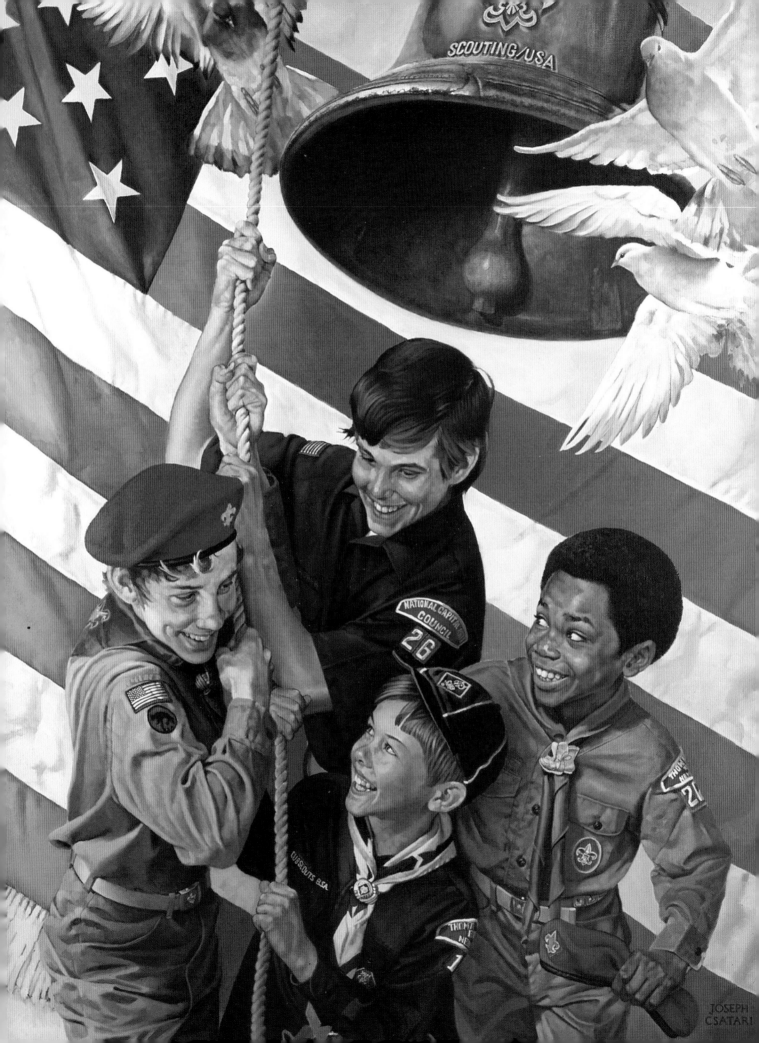

1977

THE NEW SPIRIT (left)

The Boy Scouts of America and Brown & Bigelow asked Csatari to assume the Scout calendar painting commission in the Rockwell tradition when Norman retired from his Scout work following the completion of *The Spirit of 1976* painting. *The New Spirit* is the first of more than 36 Scout paintings Joseph Csatari has completed since 1977. In 1978, Csatari left employment with the Boy Scouts and embarked on a career as a freelance illustrator, but he continues his role as Official Scout Artist, making at least one painting a year for the BSA.

Csatari painted a new handbook cover below when the Scout program was updated in 1976. The cover of the eighth edition's fourth and fifth printings portrays the gamut of outdoor adventures and merit badges to illustrate the slogan "Scouting Today's A lot More Than You Think." For Scout models, Csatari tapped his son Jeff's Scout Troop 26 of North Brunswick, New Jersey. He signed the painting beneath his son's fishing waders.

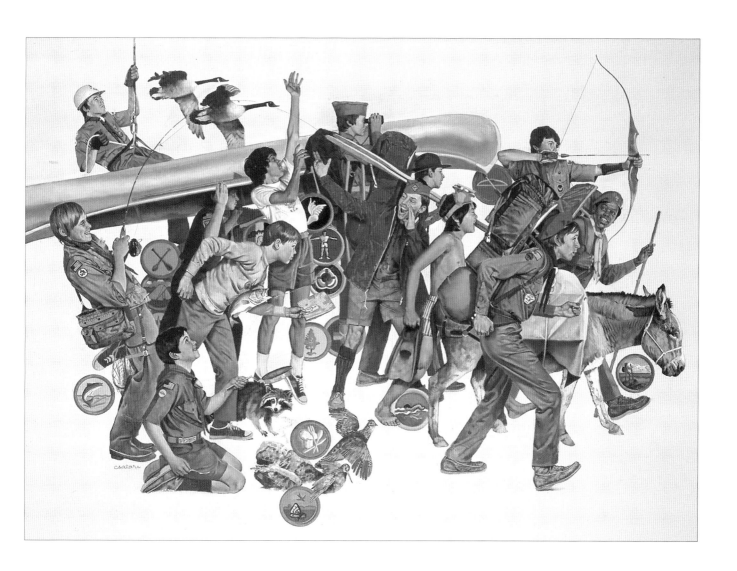

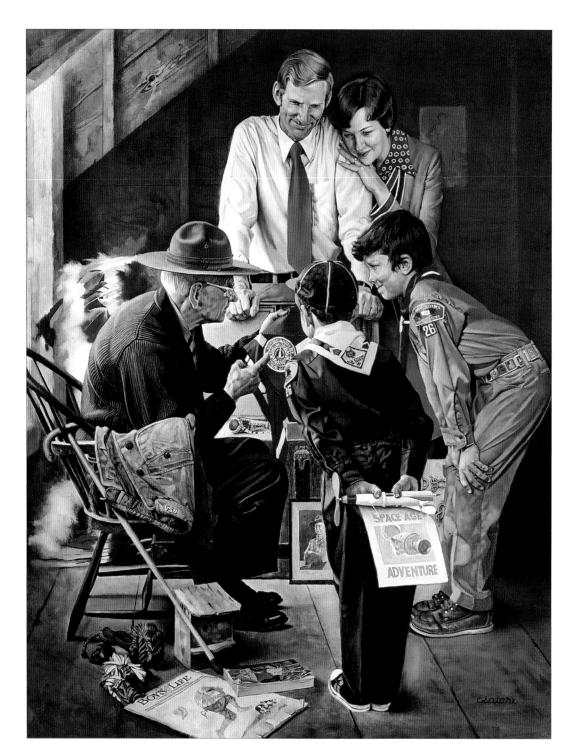

1978

SCOUTING THROUGH THE YEARS

In this oil painting, grandfather shows off a vintage jamboree neckerchief and other Scout mementos to his grandsons while mom and dad relish the family scene. Treasures pulled from his old chest in the attic include an Order of the Arrow Indian headdress, a heavy wool choke-collar Scout uniform, elaborately carved and painted neckerchief slides, a 1929 Scout Handbook whose cover is illustrated by Norman Rockwell, an early edition of *Boys' Life* magazine, and a framed photograph of Scouting founder Robert Baden-Powell.

1979

EAGLE SERVICE PROJECT

Candidates for Scouting's highest rank must plan and complete an approved community service project. There are many other requirements, but this is the one Eagle Scouts say is the most daunting. The project must be a significant undertaking and the Scout must demonstrate leadership by recruiting and supervising helpers. But success leads to admittance into an elite fraternity. Since 1912, only 1.7 million young men have achieved the honor. It's good company to share. Some particularly accomplished Eagle Scouts include the late President Gerald R. Ford, Neil Armstrong, the first man on the moon, astronaut James A. Lovell, Jr., H. Ross Perot, founder of Perot Systems Corp., Michael Bloomberg, the mayor of New York City, Stephen G. Breyer, associate justice of the United States Supreme Court, J. Willard Marriott Jr., Chairman of Marriott International, Inc., and the late business leader, adventurer, and past president of the National Eagle Scout Association Steve Fossett.

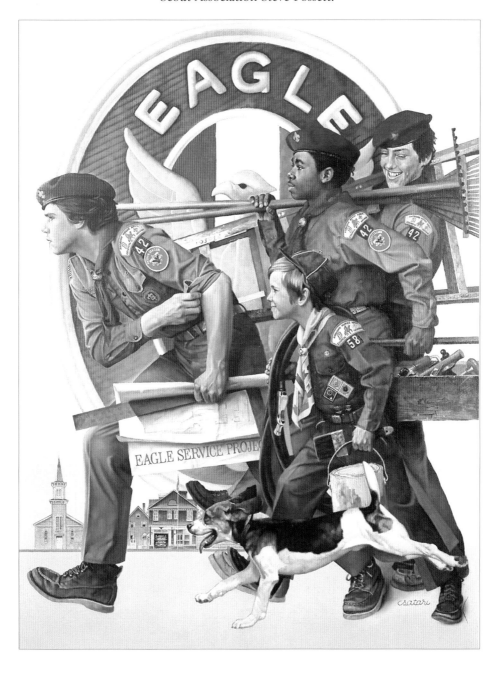

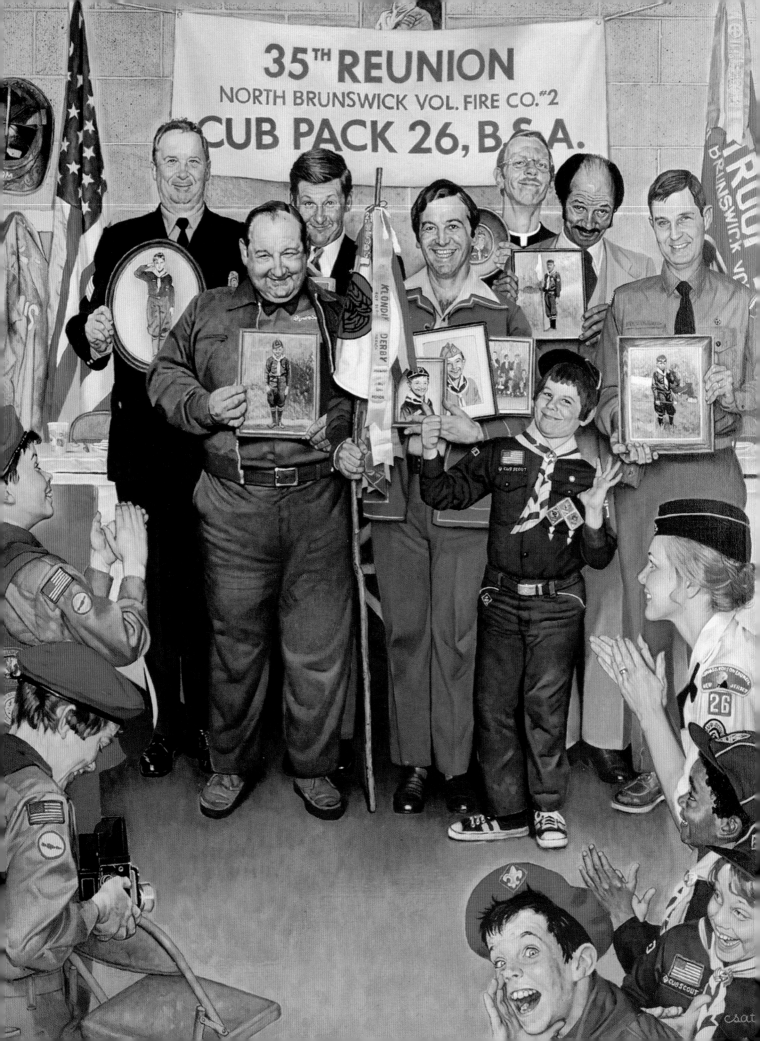

1980

THE REUNION

In this calendar painting, Cub Pack 26 hosts a reunion for former members who have matured into outstanding contributors to the community. Wouldn't you agree that these gents look rather proud of their days in the Cub Scouts? Just as Rockwell did, Csatari relies on his family, friends, old high school chums, and neighbors to pose for photographs. The Cub Scout in this painting shown proudly pointing toward his father is Christopher Dincuff, Csatari's young friend and model, who was nine years old at the time he and his father Jim posed for this painting. Chris, a generous and gifted community leader, lost his life at age 31 while working as a commodities trader in the North Tower of the World Trade Center on September 11, 2001.

1981

AFTER HOURS

A timeless theme in Scouting is mentoring to younger Scouts; here a Scoutmaster demonstrates splinting and other First Aid treatments for bone fractures. First-aid is an important skill that Scouts learn at every level of their advancement. Throughout the organization's history, tens of thousands of Scouts and leaders have applied First Aid techniques that they learned during training sessions like this. Exceptional examples of First-Aid heroism and lifesaving are recognized through Meritorious Action or Lifesaving awards given to deserving Scouts through local councils by the National Court of Honor.

1982

THE PATROL LEADER

The patrol system initiated by Scouting founder Robert Baden-Powell allows Scouts to work together in a smaller group within the larger troop. It is the duty of the patrol leader to organize, lead, and train newer Scouts. He's typically an older Scout who wears the green patch with dual bars as seen on the left arm of the boy here who's showing his patrol how to load a backpack. Role modeling for impressionable lads is a hefty responsibility. When Csatari was a Scout, he recalls his patrol leader teaching him the technique for throwing a hatchet into the trunk of a dead tree. When his Scoutmaster asked him to demonstrate his new skill for a merit badge test, the Tenderfoot obliged with an skillful toss from 20 feet—*thunk*. "You fail, Csatari," his Scoutmaster scolded. "You never *ever* throw an axe!"

1983

FAMILY CAMPING

Family involvement is a big part of the Cub Scouting program, which offers activities to help unite all types of families—two-parent, single-parent, and nontraditional families. The goal is to support and strengthen families by helping parents and guardians teach a system of core values and beliefs while having a lot of fun. Going on a campout as the family in this painting is doing is just one possibility. There are dozens of ways the entire family can get involved in Scouting. To encourage participation, Scouts can earn the BSA Family Award patch by completing 10 wide-ranging family activities within a 12-month period.

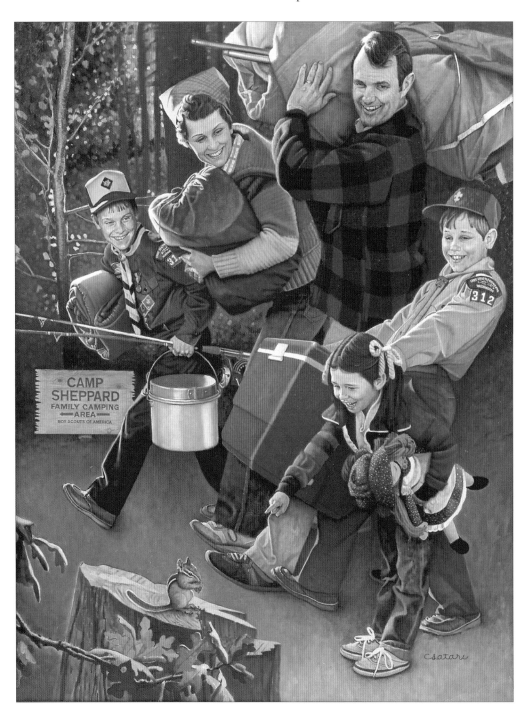

1984

THE STRENGTH OF SCOUTING THROUGH VOLUNTEERS

Scouting simply could not exist without dedicated volunteers who provide leadership and mentoring to Cub Scout Packs, Boy Scout Troops, and Venturing Crews. The Boy Scouts of America wanted this year's painting theme to honor community members from all walks of life, so Csatari portrayed parents, a coach, a pastor, Scoutmasters, and leaders from business and service industries receiving a simple "thank you" from a Scout.

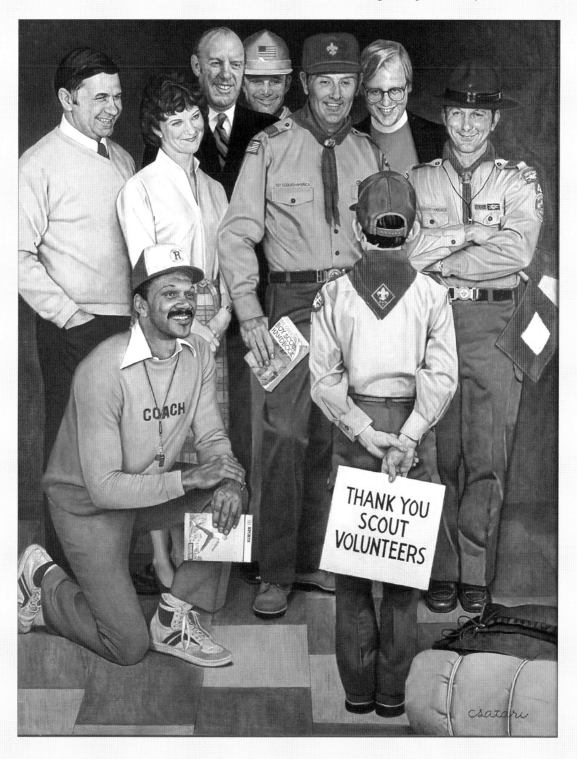

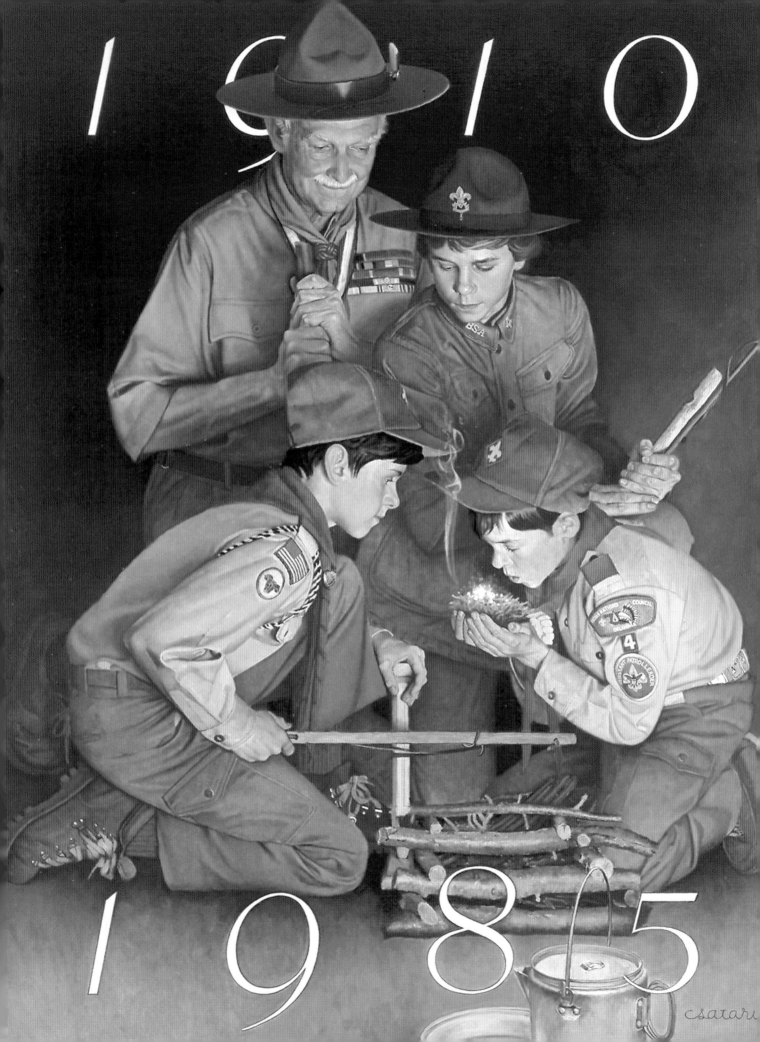

1985

THE SPIRIT LIVES ON

This oil painting celebrating the 75th anniversary of the founding of the Boy Scouts of America shows Lord Baden-Powell and a Scout from 1910 watching over Scouts from 1985 building a campfire. Csatari spent hours practicing "fire by friction" with a bow drill and fireboard to research the proper fire-lighting technique for this picture. One Scout is shown carefully collecting an ember in a nest of tinder and blowing on it to encourage a flame. Csatari used a model who resembled Baden-Powell, then relied on archive photographs of the Chief Scout of the World to render his likeness.

1986

IT'S A *BOYS' LIFE*

Three Scouts enjoy a meal while reading the *Boys' Life* cover story about San Francisco 49ers quarterback Joe Montana. Still one of the largest circulation magazines in the country at 1.1 million Scout and 200,000 non-Scout subscribers per month, *Boys' Life* thrills readers with stories about sports, outdoor adventures, hobbies, and Scoutcraft, and exciting fiction and comics. *Boys' Life* has always been about good writing. One of the magazine's earliest contributors was Jack London, who wrote *King of the Mazy May* for the second issue in 1911. Other famous writers who have published original work in *Boys' Life* include Rudyard Kipling, P.G. Wodehouse, Orville Wright, Robert E. Peary, Pearl Buck, Zane Grey, Isaac Asimov, Arthur C. Clarke, Isaac Bashevis Singer, Ray Bradbury, Alex Haley, Gary Paulsen, and Thomas McGuane. And in the tradition that started with Norman Rockwell, the magazine continues to tell its stories through the art of the nation's most talented illustrators, including Bart Forbes, Paul Calle, Marvin Friedman, Jack Unruh, and C.F. Payne among many others.

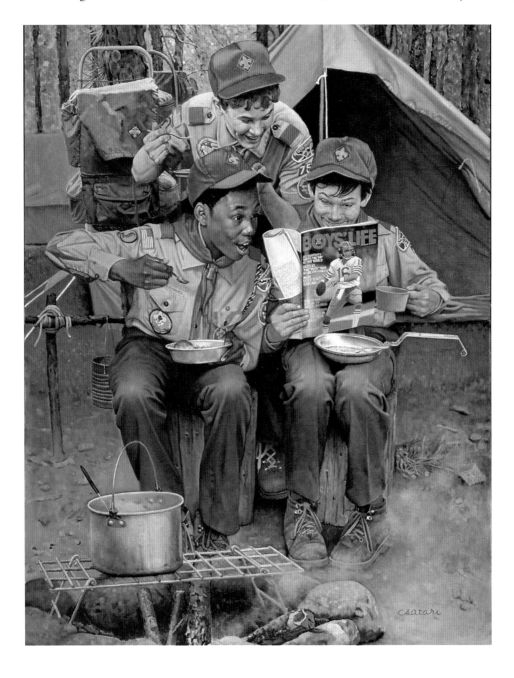

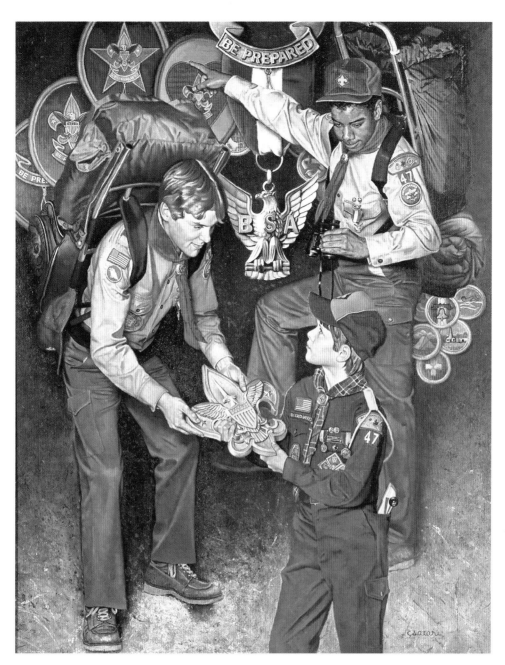

1987

VALUES THAT LAST A LIFETIME

Second Class, First Class, Star, and Life Scout badges and merit badges for camping, first aid, swimming, and citizenship in the community and nation mark the trail toward the Eagle Scout award for this Webelos Scout, who is being handed the emblem of the Tenderfoot rank. Created in 1941, the original Webelos program filled the need for a transition program from Cub Scouting to Boy Scouting. The consonants in WeBeLoS stood for the Cub Scout rank progression (Wolf, Bear, Lion, Scout) culminating with graduation into a Boy Scout troop. Webelos was also the name of the made-up tribe to which all Cubs belonged. Later, the Lion rank was discontinued, but the name remained to stand for **WE**'ll **BE LO**yal **S**couts. This painting is reminiscent of Rockwell's 1960 calendar *Ever Onward* (page 76), including the abstract background. Csatari's son Joe modeled for the Scout handing down the fleur-de-lis to the Webelos. That's a Pinewood Derby car in the younger boy's back pocket.

1988

WINTER CAMPING SCENE

Scouts don't hibernate in wintertime. They camp in the snow.
Learning to do so comfortably and safely in frigid weather is one
of the great outdoor adventure challenges of Scouting. But with
good leadership, preparation, and training (and warm socks), winter
camping can be a magical experience. There's nothing quite as
beautiful as the silent winter woods after a fresh snowfall, or quite
as tasty as a hot breakfast of eggs, sausage, oatmeal, and hot cocoa
after squirming out of a sleeping bag and into a crisp morning
campsite. There was no snow available when Csatari photographed
his models for this winter-theme painting. "We shot the pictures in
my yard on the hottest day of the summer," he says. "People in cars
were slowing down to see why boys were wearing winter coats in the
middle of July."

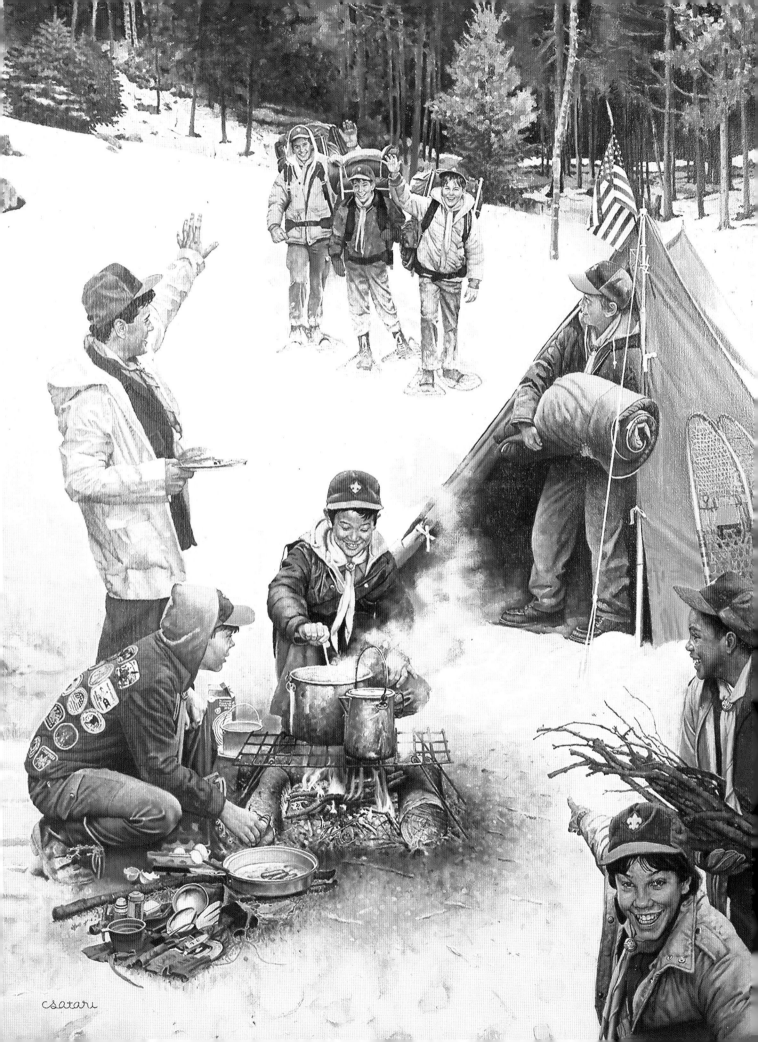

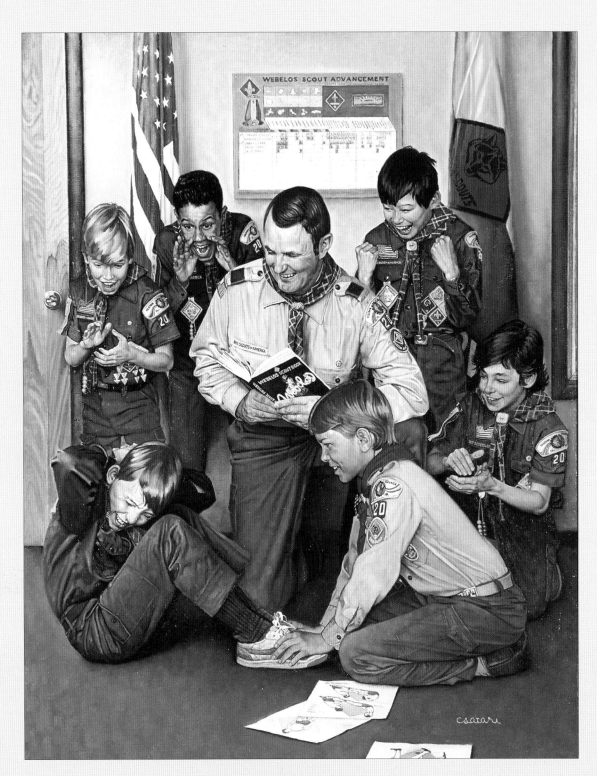

1989

YOU CAN DO IT

Today's youth are considered the most inactive generation in the history of our country, which makes the BSA's long commitment to encouraging physical fitness through its programs even more crucial. The Webelos Scouts here encourage their pal as he does curl-ups for his Fitness activity badge. The chart on the wall tracks the boys' progress to get fit and, maybe, build washboard abs!

1990

THE SCOUTMASTER

For this painting, Csatari drew inspiration from Rockwell's 1952 work *The Spirit of Kansas City*, which shows a man striking this same rolling-up-sleeves pose and holding construction blueprints against a background of a cityscape. "He's building for the future," says Csatari. "I wanted to convey the same message of the Scoutmaster who's shaping our future through the boys he leads. So the model had to look strong, determined, wise, kind, and fun—all those things in one because that's what it takes." *The Scoutmaster* is the last painting used for a Scout calendar. Brown & Bigelow discontinued calendar production after 1990, though the tradition of depicting Scouting on canvas continues to this day.

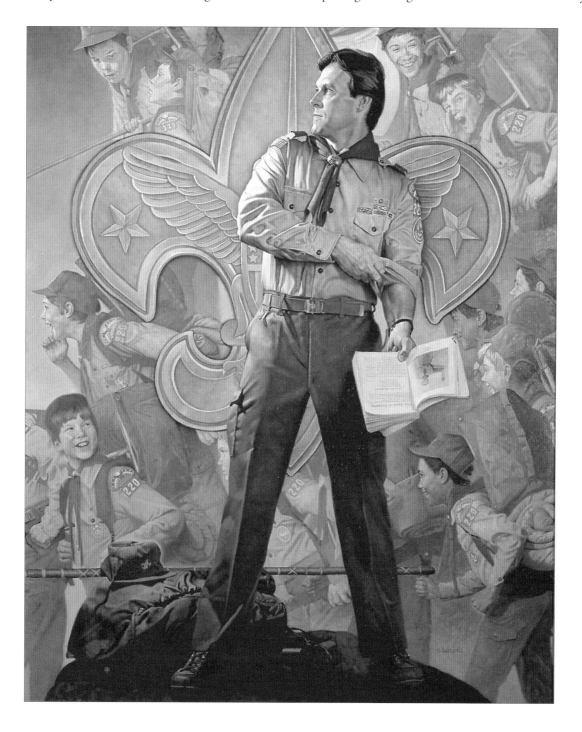

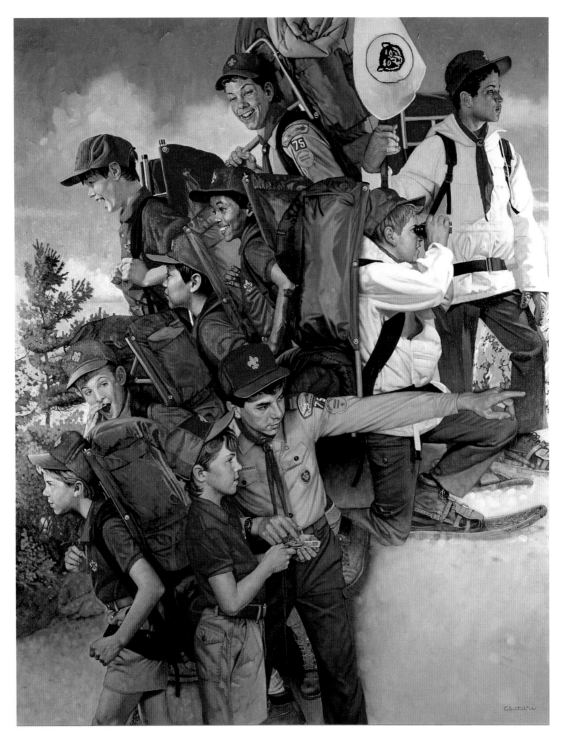

1991

SCOUTING FOR ALL SEASONS

Scouting is a year-round adventure of outdoor activity as shown in this oil painting, which illustrates Scouts snowshoeing in their winter anoraks and backpacking in summertime short sleeves. As seasons change and official Scout gear and apparel styles are updated, Csatari must restock the prop shelves in his studio with new shirts, trousers, caps, and camping equipment to represent Boy Scouts of America's latest look. But while fashion is fleeting, the venerable Scout compass isn't; it has been helping boys take their bearings for 100 years.

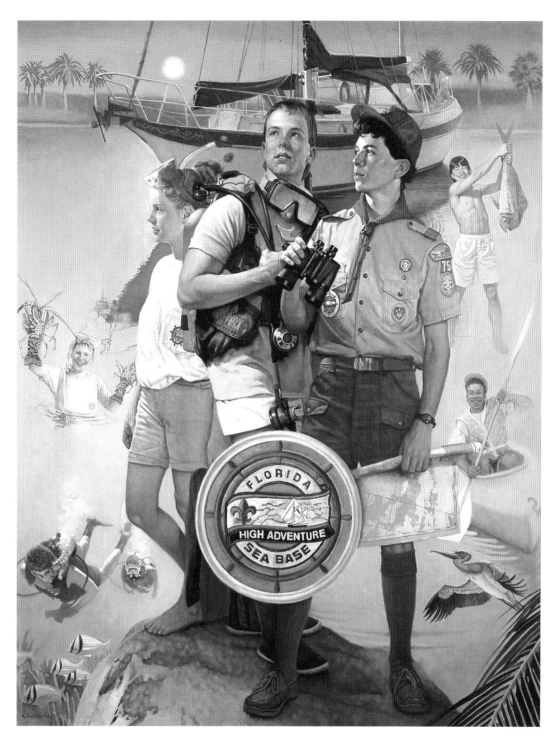

1992

FLORIDA SEA BASE

This work featuring scenes from the Florida National High Adventure Sea Base in the Florida Keys is the first BSA painting to include a girl, a member of Scouting's Explorer program. The Sea Base is one of four BSA high adventure areas where tens of thousands of Scouts sail, camp, canoe, climb, and hike each summer. The others are the Philmont Scout Ranch, the Charles L. Sommer's Wilderness Canoe Base in Wisconsin, and the Maine High Adventure Area.

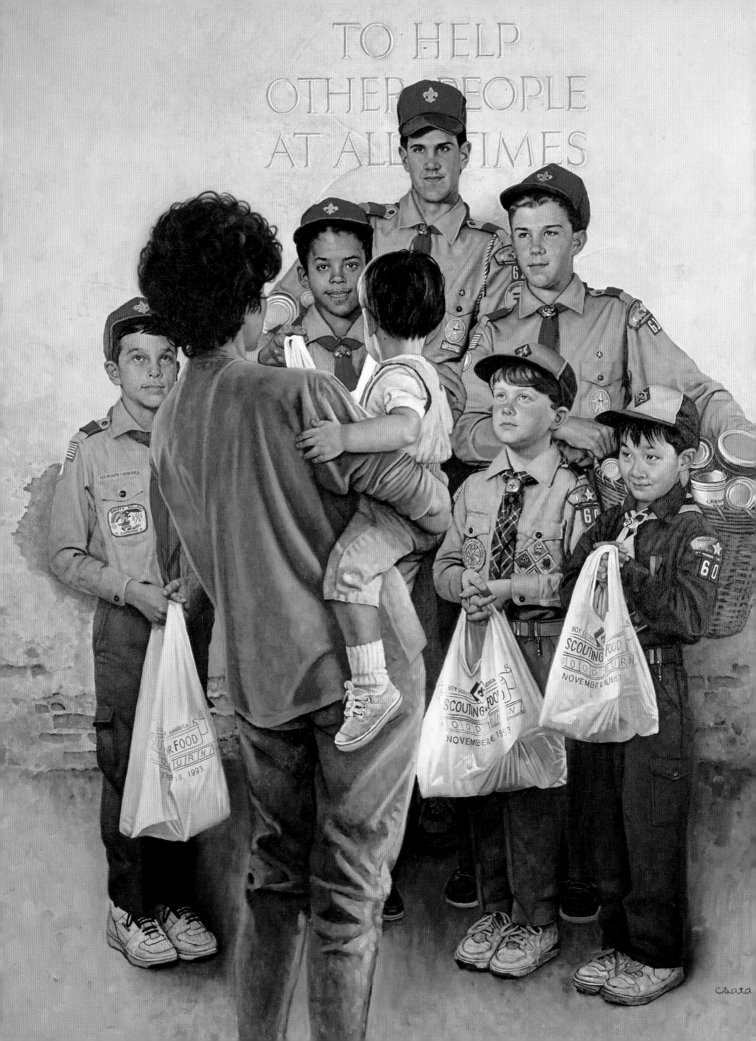

1993

A GOOD TURN

A Good Turn represents the Scouting For Food stewardship program. Every year Scouts collect canned goods to stock community food pantries and homeless shelters in order to feed tens of thousands of needy local residents. The original pencil sketch (below) showed only the Scouts holding bags of food. "I felt that something was missing," says Csatari. "I added the needy mother and her child as recipients of the food to try to make a better composition and convey a stronger message." The stone wall in the background carries the words from the Scout Oath, "To Help Other People At All Times."

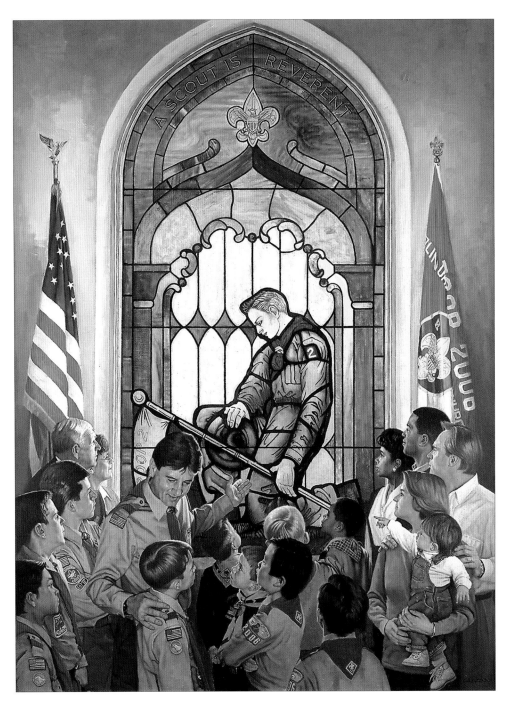

1994

A SCOUT IS REVERENT

The Boy Scouts of America again returns to the theme of faith, a value crucial to its mission to help boys learn to make sound ethical judgments throughout their lives. Rockwell illustrated this theme in three Scout oil paintings. In Csatari's *A Scout is Reverent,* the artist uses a stained glass window showing a Scout kneeling in prayer as his focal point. He adapted this from a stained glass window in Trinity Episcopal Church of Torrington, Connecticut, which was installed in 1966 to mark the 50th anniversary of Troop 2, 1916–1966. In the actual church window, the emblems of the First Class and Eagle Scout badges flank the seal of the Episcopal Church. By eliminating these and other elements, Csatari made the painting non-denominational and simplified the design to direct attention to the praying Scout.

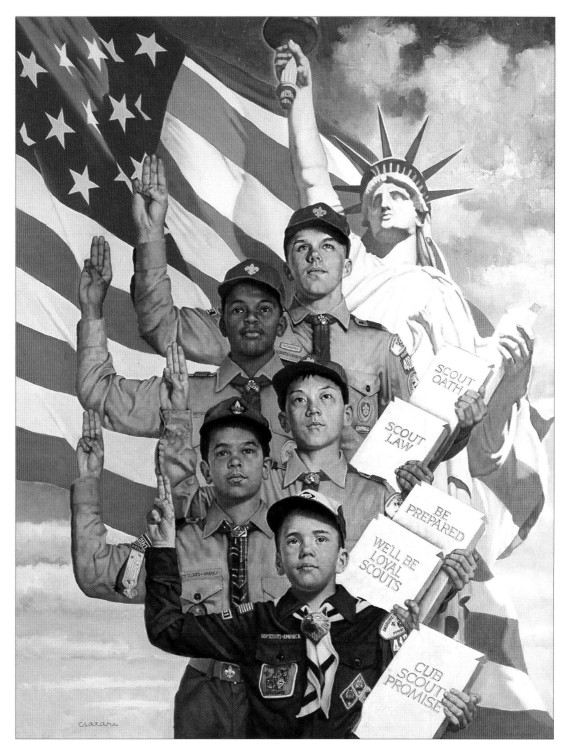

1995

CHARACTER COUNTS

In this rhythmic composition, the Scouts strike poses similar to Lady Liberty's, with right arms raised and hands holding tablets. Their tablets read "Scout Oath," "Scout Law," "Be Prepared," "We'll Be Loyal Scouts," a saying whose initials form "Webelos," and "Cub Scout Promise." This painting is a good one for comparing the changing styles of the Scout uniform. Flip back to the Rockwell paintings on pages 24, 62, and 99 for a retrospective of Scout khaki fashion.

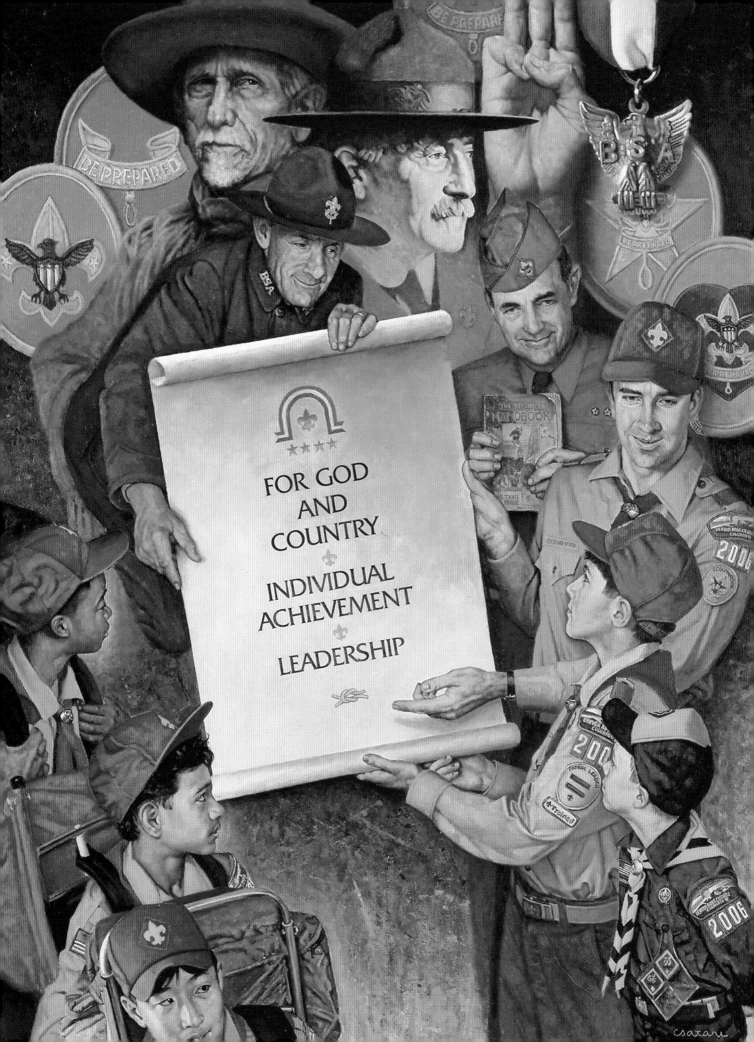

1996

PASS IT ON (left)

All the symbols of Scouting are found in this work, including the badges for ranks Tenderfoot through Eagle Scout, the three-fingered Scout sign, and Scouting founding leaders Daniel Carter Beard (with the beard) and Robert Baden-Powell. The men around the scroll represent three generations of the family of BSA national president Norman Augustine. He's depicted in the center holding the Scout Handbook; that's his father holding the scroll and his son below him.

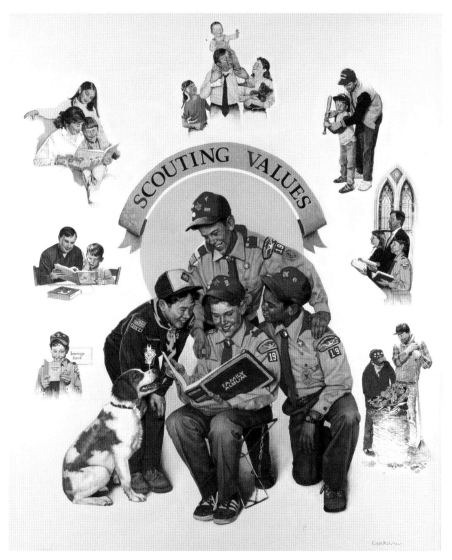

1997

SCOUTING VALUES (above)

Scouting is a values-based program that teaches good conduct, respect for others, honesty and citizenship skills to its members. Csatari illustrates some of those values through vignettes surrounding the main image of this painting. After completing the charcoal rough of this picture, Joe realized that the picture was missing an emotional element. So he painted a dog next to the Cub Scout. That's a trick Csatari learned from his mentor Rockwell: you can enhance the appeal of almost any painting by adding a dog.

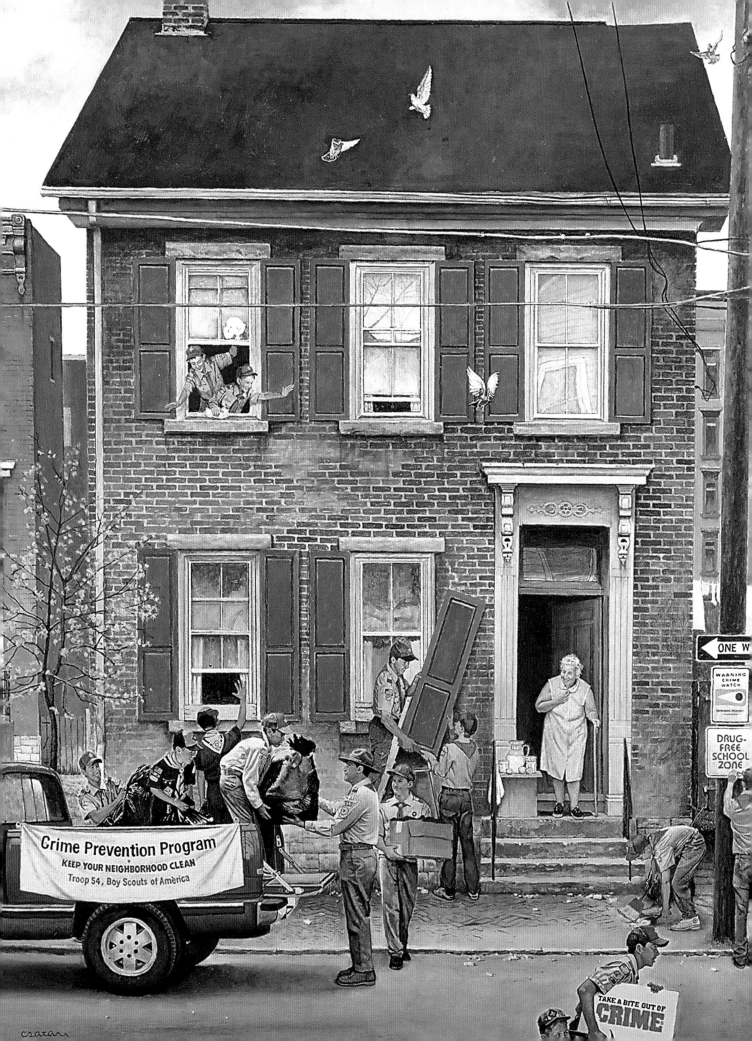

1998

URBAN GOOD TURN

The Boy Scouts of America and the National Crime Prevention Council launched a new badge and a crime prevention program in 1996. In the years that followed, hundreds of thousands of youths from all facets of Scouting participated in neighborhood cleanup projects, like this one, to reduce the incidence of crime.

"I never like to be without my camera," says Csatari who always keeps an eye peeled for reference material. One day while driving through Bethlehem, Pennsylvania, he came across some brick row houses that perfectly captured the urban atmosphere he was looking to show in *Urban Good Turn*. He stopped his car in the middle of the street and jumped out to snap pictures of the house. "I had to explain what I was doing to a police officer who pulled up behind me," Csatari laughs. Now the artist carries a card issued by the police department identifying him as the official Boy Scout artist, which he can show to prospective models he finds at malls, parks, and other public places, and for encounters with the law such as this.

1999

CHARLES L. SOMMERS
WILDERNESS CANOE BASE

This Northern Tier National High Adventure Base in Ely, Minnesota, hosts hundreds of paddlers each summer for 50- to 150-mile long treks in the Boundary Waters Canoe Area Wilderness. It's common for Scouts to see bald eagles, moose, wolves, bear, and baby loons riding on their mamma's backs during their six- to 10-day long canoe adventures. The young man holding the red-tipped canoe paddle and wearing the attire of a French voyageur at the back of the painting represents the famed "Charlie guides," members of the trail staff who take crews into backcountry on summer canoe and winter camping trips. The guides, or interpreters as they are now referred to, teach their charges the traditional voyageur greeting, *Hol-Ry*! When voyageurs encounter one another on a portage trail, it's customary for one to address the other with "Hol-Ry" and the other to respond by saying "Red-Eye." The greeting stems from the early 1950s when Charlie crews carried a stiff rye cracker with the trade name Hol-Ry as part of their trail food. The term Red-Eye comes from the name of the noonday drink of the early loggers of the Ely area.

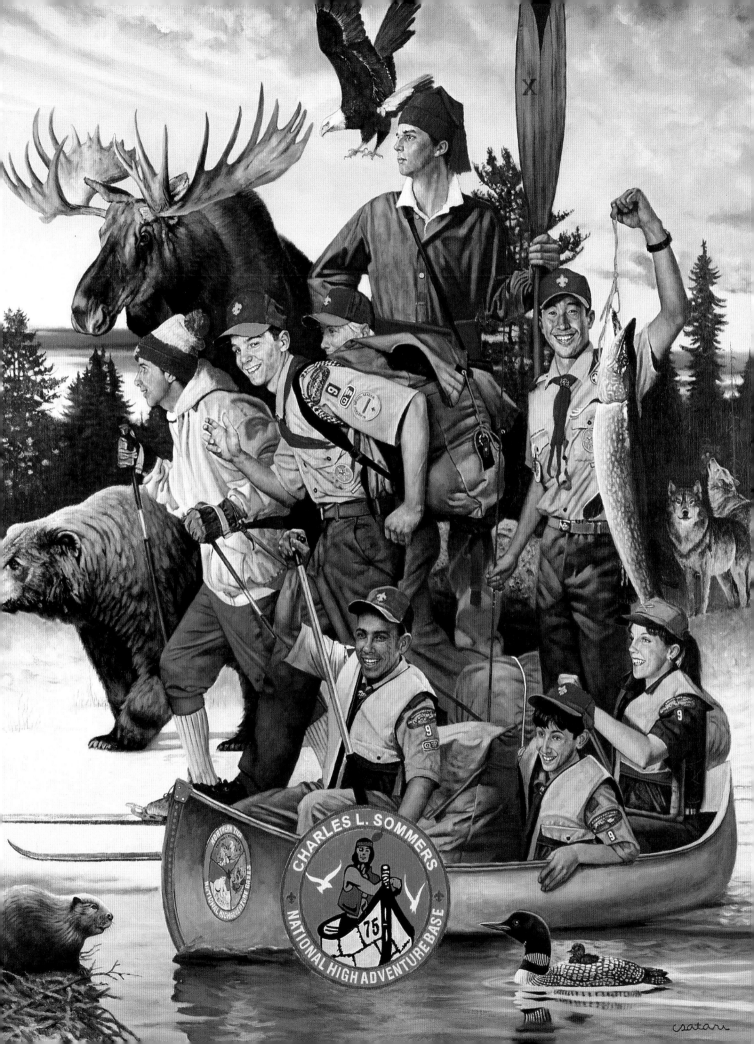

CHARLES L. SOMMERS

NATIONAL HIGH ADVENTURE BASE

75

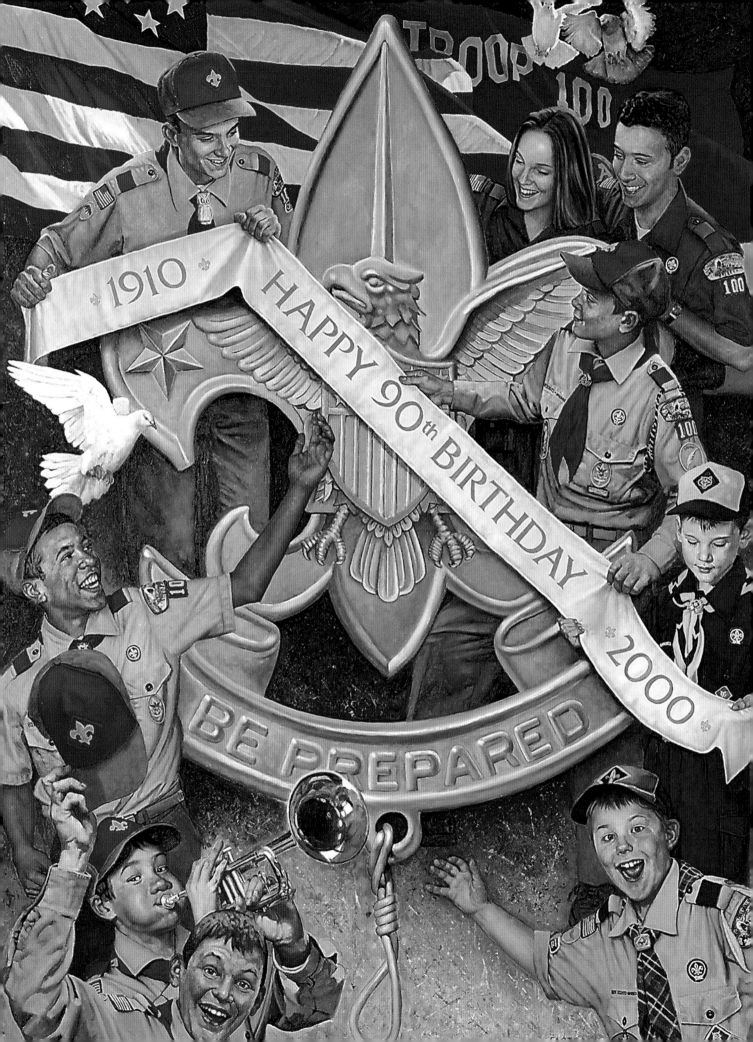

2000

HAPPY 90TH BIRTHDAY BSA (left)

One of two paintings commemorating the 90th anniversary of the Scout movement in the U.S., founded in 1910. Cub Scouts, Webelos, Boy Scouts, and Explorers throw a birthday bash in *Happy 90th Birthday BSA*.

OUT OF THE PAST INTO THE FUTURE (below)

Commissioned by the Boy Scouts of America's 1910 Society, this painting features, from left, Ernest Thompson Seton, Daniel Carter Beard, Waite Phillips, and Theodore Roosevelt, all of whom played important roles in shaping the BSA.

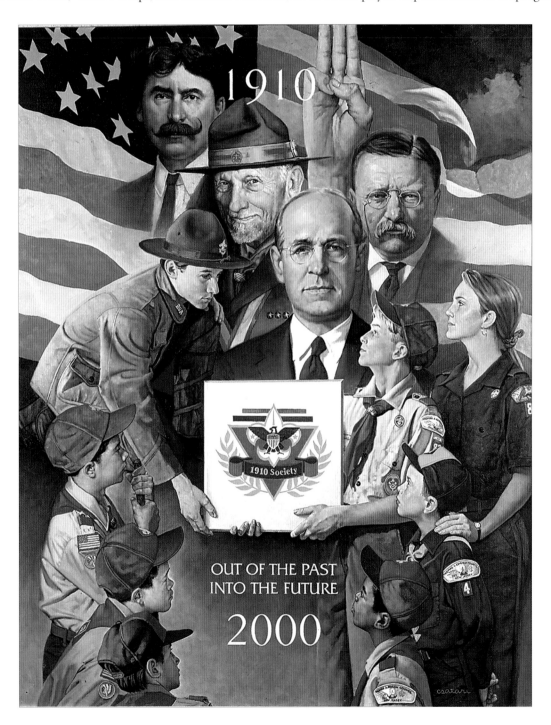

2001

JAMBOREE 2001

This energetic picture commemorates the 2001 National Scout Jamboree attended by 40,000 youth and adult leaders at Fort A.P. Hill in the Virginia countryside. The jamboree, held every four years, is an opportunity for Scouts from around the country to meet for fun, Scoutcraft exhibitions, musical performances, sports activities, and patch trading.

Commissioned to celebrate the 90th anniversary of *Boys' Life*, this illustration, right, appeared on the January 2001 cover of the magazine. It depicts Scouts engaged in high adventure and sporting activities while the background shows five boys from the early days of Scouting in sepia tone. While Csatari illustrated dozens of articles for the magazine when he was its art director in the late 1960s, he hadn't contributed a cover painting until this one.

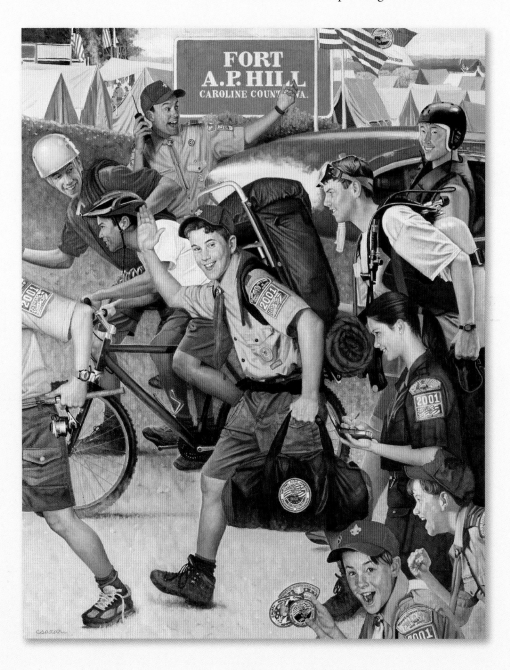

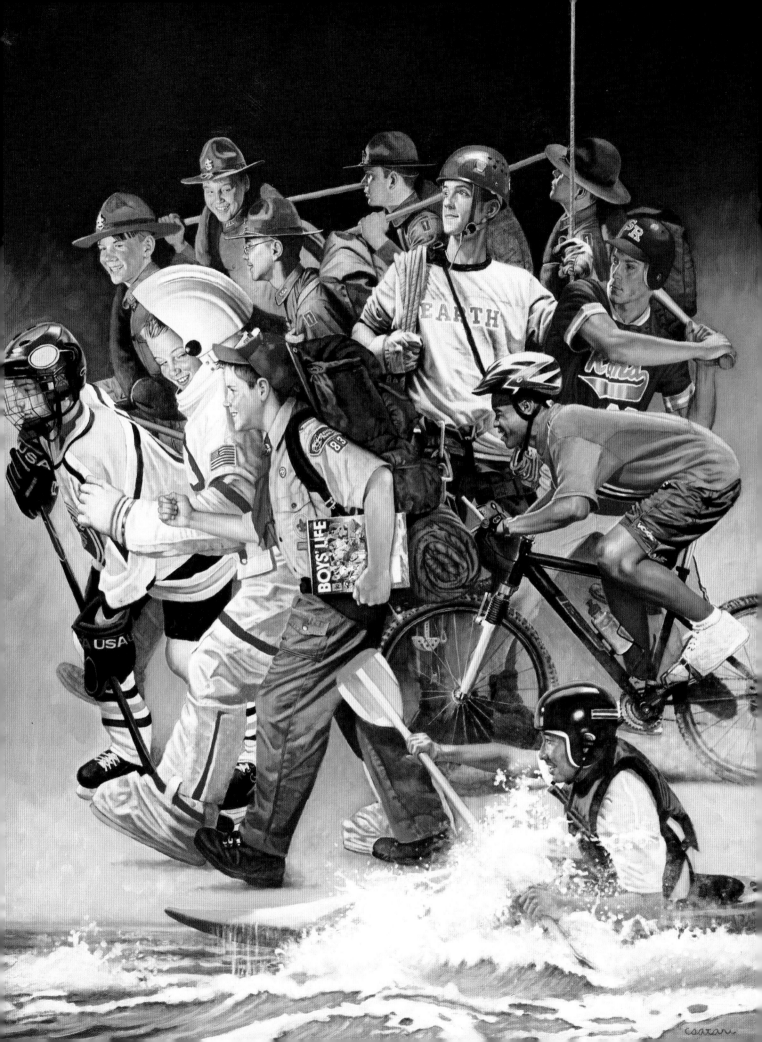

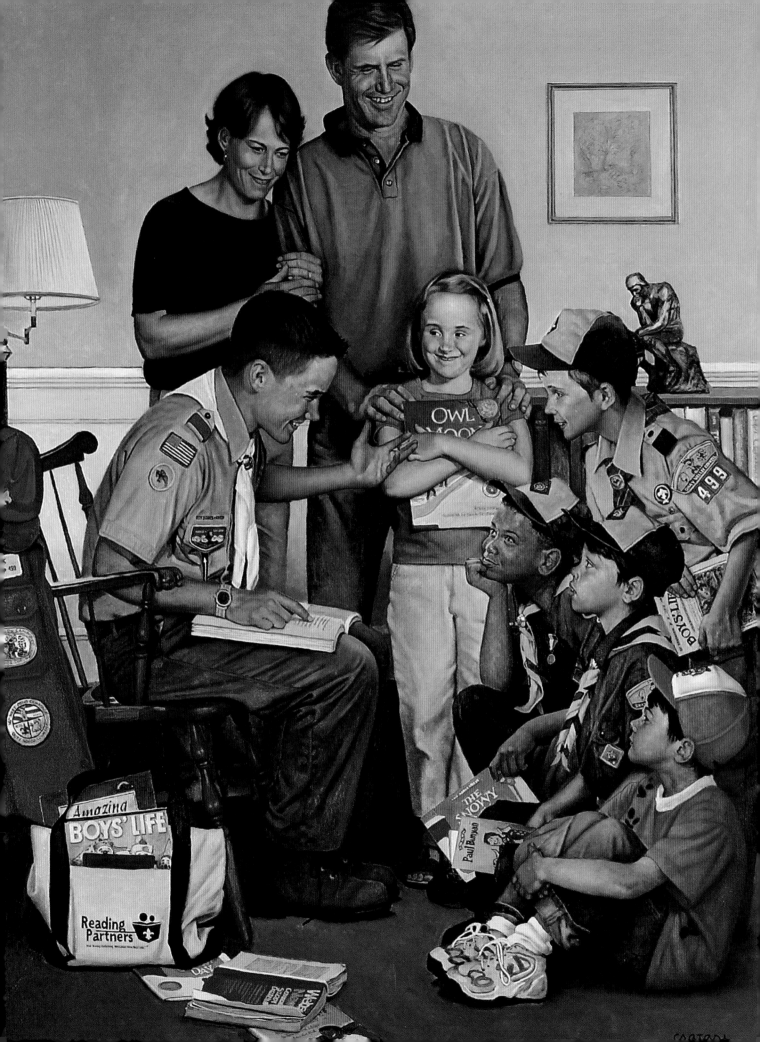

2002

READING PARTNERS

The mission of *Boys' Life* magazine has always been to entertain and educate America's youth, and open their eyes to the joys of reading. To enhance that effort, *Boys' Life* piloted Reading Partners, The Buddy Tutoring Program, which helped preschool through third grade children develop literacy skills. The Boy Scouts of America selected the Reading Partners program as the theme for this 2002's Scout painting to promote the magazine's literacy initiative. After more than 1,000 issues and four billion readers, *Boys' Life* continues to draw young people to the wonders of reading. And today the magazine publishes three demographic editions with 16 to 20 age-specific pages in each to meet the reading-level needs of Tiger Cub and Cub Scout subscribers through age eight, Cub Scouts and Webelos Scouts age nine and older, and Boy Scout subscribers age 11 and older. Csatari added a few appropriate props to this painting. The copy of *Boys' Life* in the Webelos' hand at right is a reprint of the very first 1910 issue of the magazine. Also, notice the reproduction of Auguste Rodin's famous bronze sculpture *The Thinker* on the bookshelf.

2003

PREPARED TO DO A GOOD TURN (right)

The Boy Scouts of America honors the first responders to the September 11th 2001 attacks with this dramatic work depicting firefighters, police, rescue workers and Scouts with the remnants of the World Trade Center buildings in the background. Within hours of the attacks, and in the weeks that followed, Scout units supported the rescue and recovery efforts by providing bottled water and other supplies to emergency and military personnel, and organizing blood drives, Red Cross fund-raisers, and supply collections.

"I drew inspiration from the emergency workers, everyday Americans, and Scouts in New York, Washington, D.C., and Pennsylvania," Csatari says of the painting. Csatari wanted to depict some of the actual New York policemen, firefighters, and Port Authority emergency personnel who were on the scene that day, so he visited Ground Zero to photograph the site and meet with recovery workers. "When they learned that I was the Boy Scout artist, some of them showed me their Eagle Scout I.D. cards," he says. And one firefighter gave him a cross he had cut out of the gnarled World Trade Center steel with an acetylene torch. "It was a humbling day, both sad and inspiring at the same time," says Csatari. *Prepared to Do a Good Turn* was unveiled in September 2002 at the National Scouting Museum, where the painting became part of the collection housed in the museum's Norman Rockwell Art Gallery.

Getting the Painting Right (below)

Joseph Csatari photographs firefighters and a police officer in a firehouse in Manhattan for use as reference for his painting.

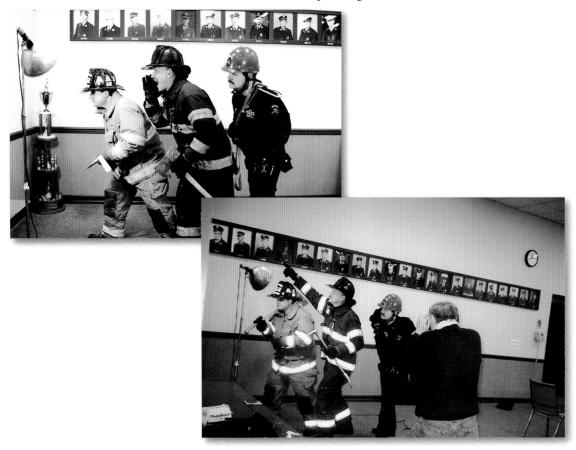

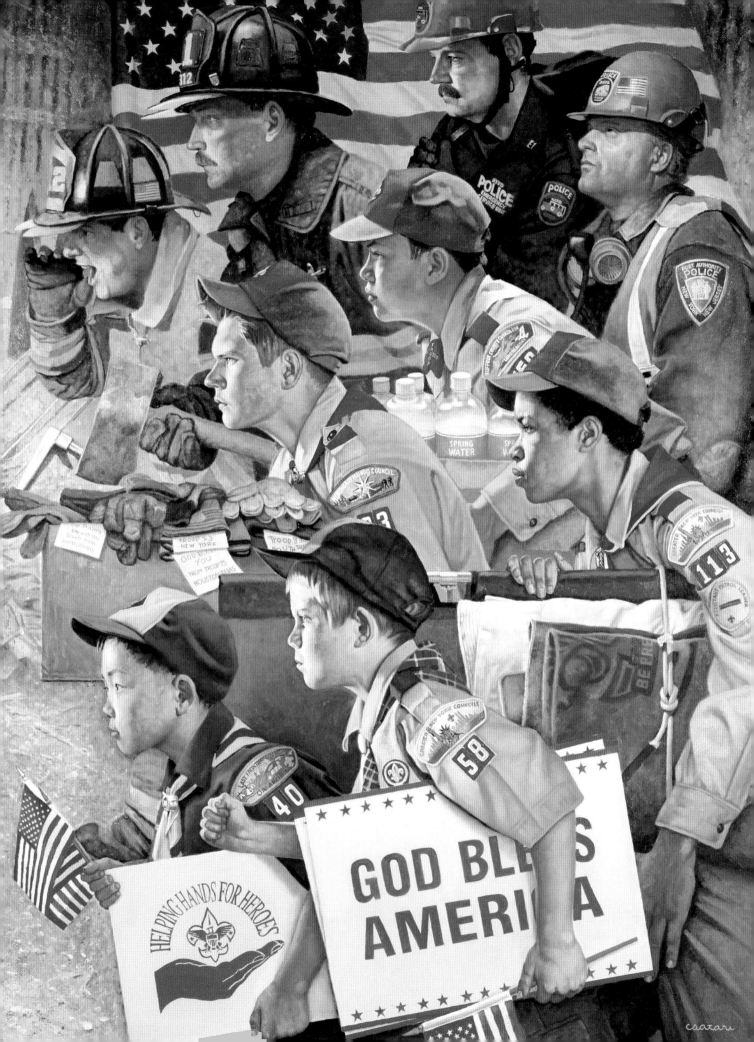

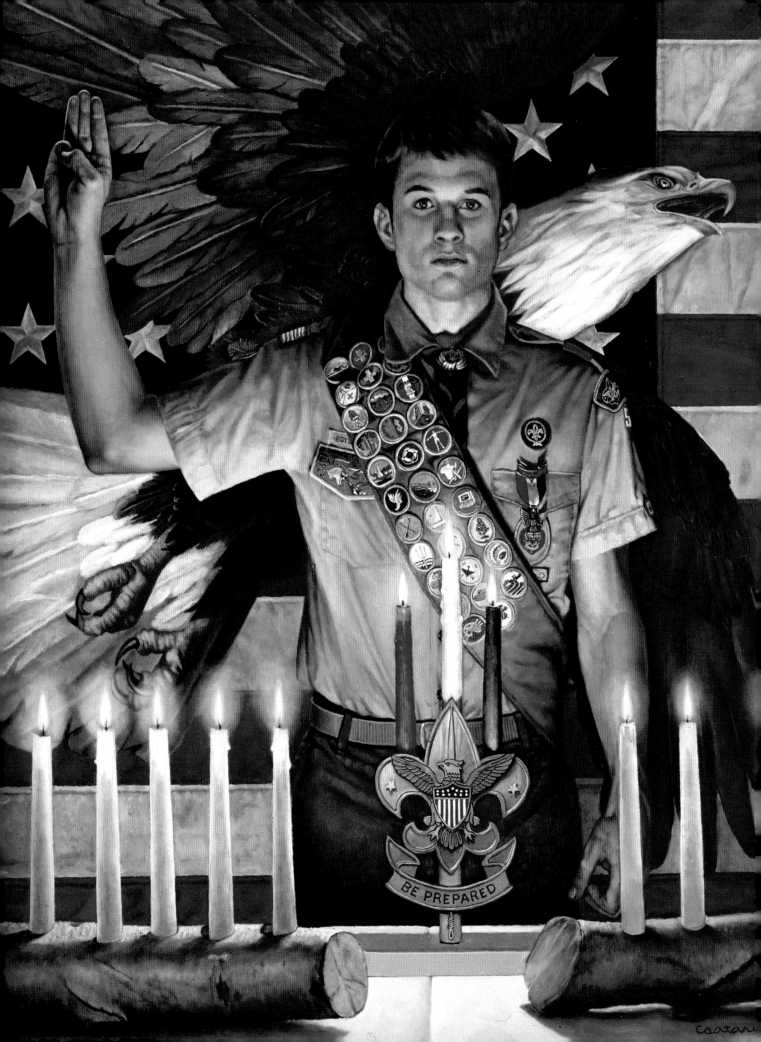

2004

EAGLE COURT OF HONOR (left)

Light from the candles is used to create an appropriate mood for a Scout's Eagle Court of Honor ceremony. The oil painting, made for the National Eagle Scout Association, was unveiled during Eagle Scout Heritage Day at the National Scouting Museum in Irving, Texas.

DREAMS BECOME A REALITY IN VENTURING (below)

The 2004 painting recognizes Venturing, the Boy Scouts of America's youth development program for young men and women, ages 14 to 20. Venturing crews are sponsored by community organizations which provide skill-building opportunities in high adventure activities, sports, arts and hobbies, religious life, and Sea Scouting.

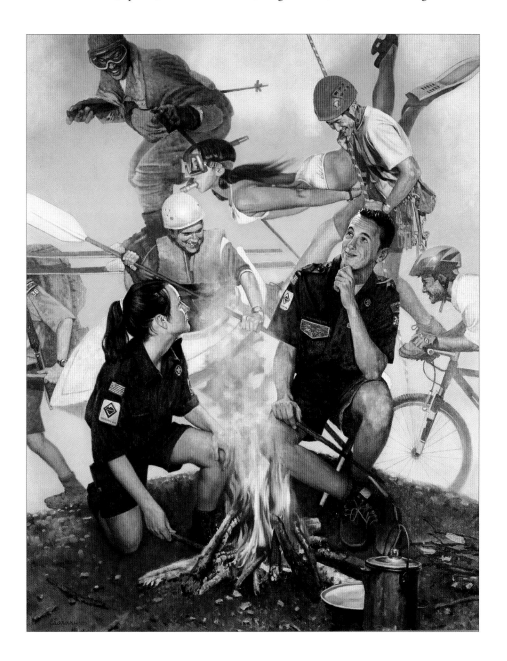

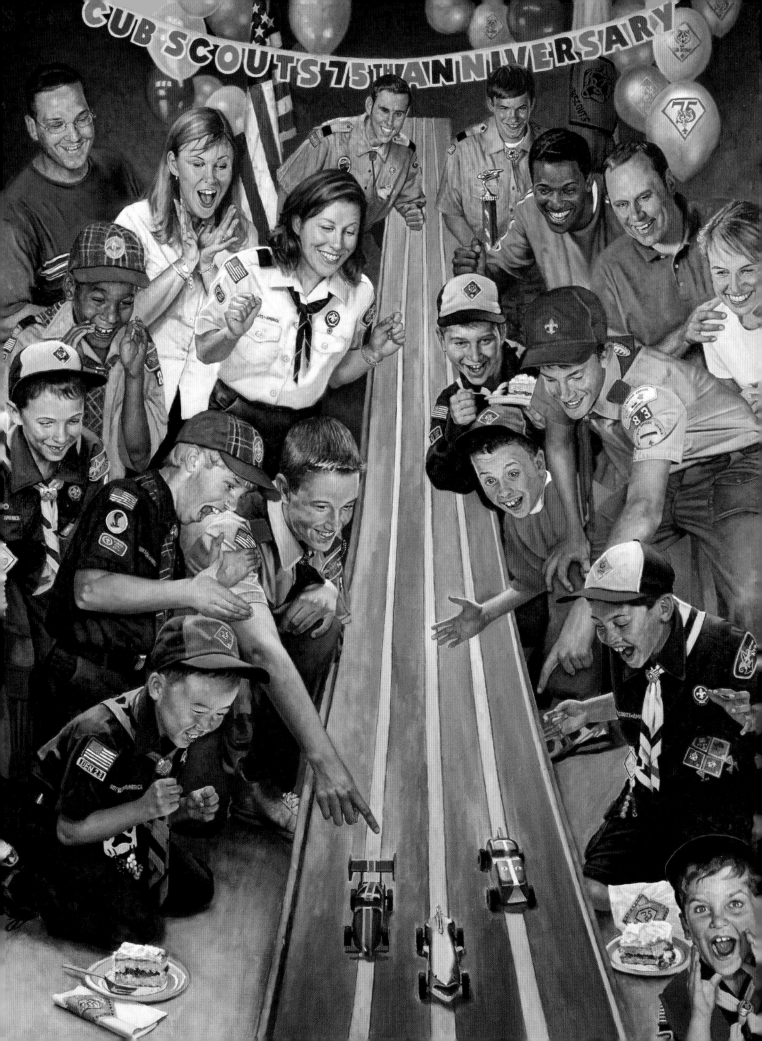

2005

CUB SCOUTS 75TH ANNIVERSARY

If you've never witnessed the spectacle of a Pinewood Derby race, you are missing one of Cub Scouting's most exciting (and loud) events. Kids work for weeks (typically with dad's help) carving and fine-tuning their cars for the big race, where families show their true competitive colors. The first Pinewood Derby was held by Pack 280C of Manhattan Beach, California in May of 1953. Thousands of races are now held each year around the country.

2006

SCOUTING HEROES

By showing the backs and profiles of the Scouts, a technique he uses often, Csatari draws the viewer's attention toward his primary focus, the portraits in this art museum scene. This painting within a painting serves a dual purpose—to suggest that Scouting builds future leaders of the community and to honor those role models who give back to Scouting through their volunteer work. And while the Scouts admire their heroes, the young boy appears to be doing the same.

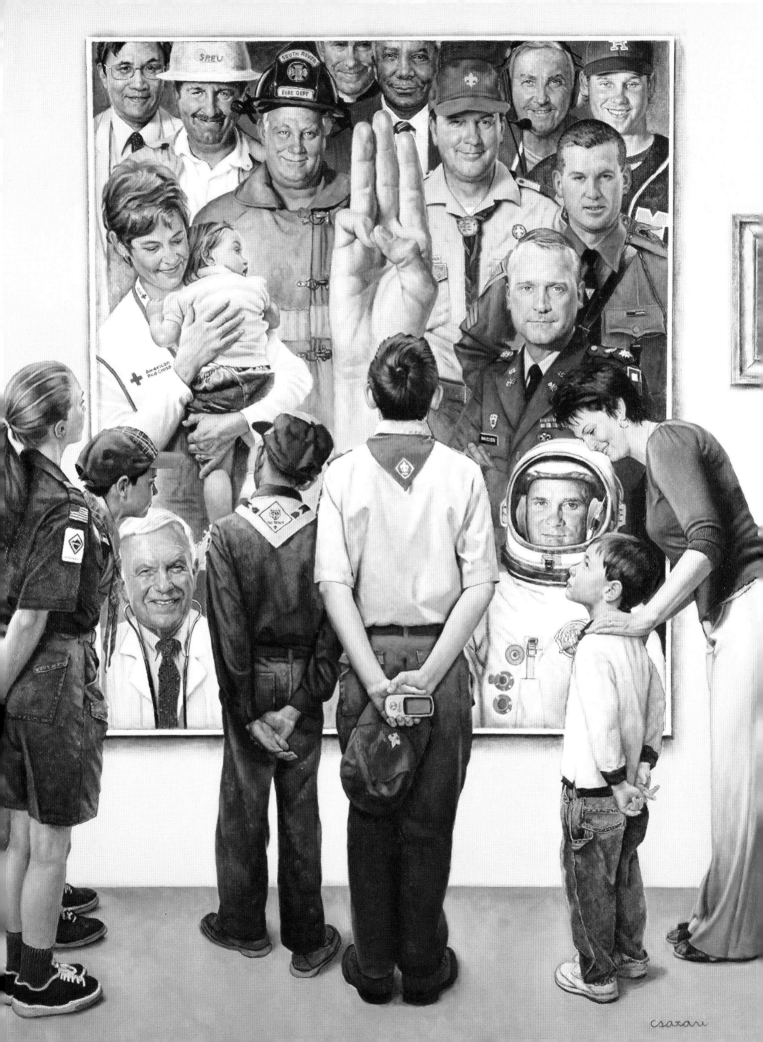

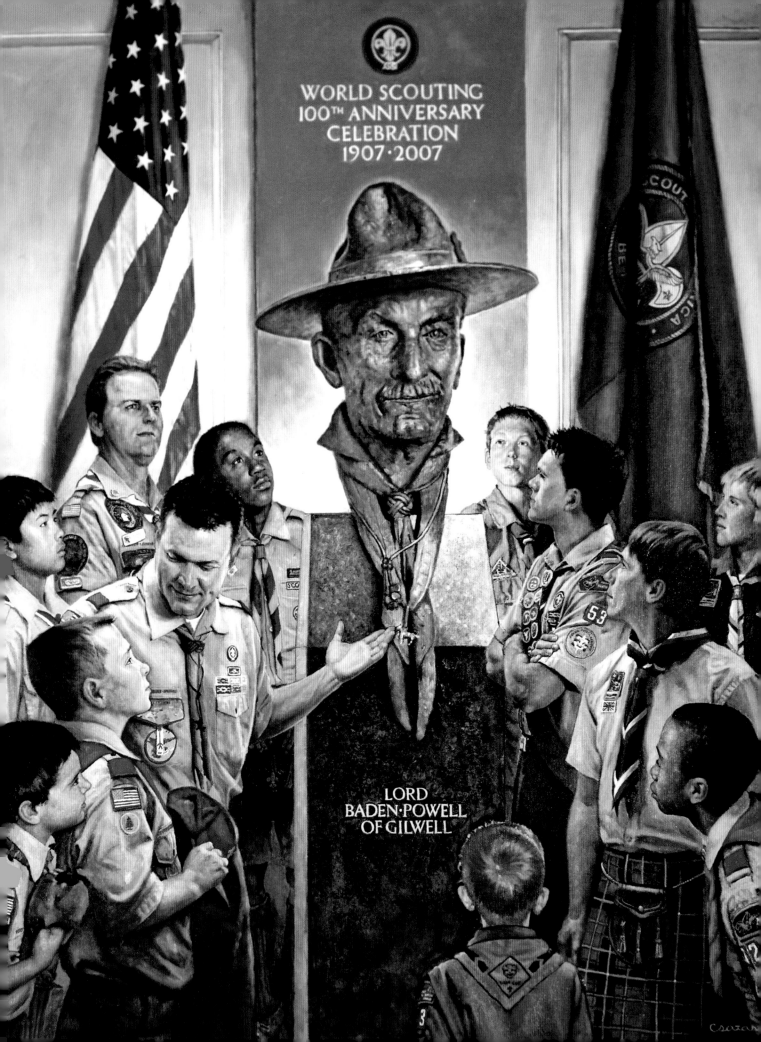

WORLD SCOUTING
100TH ANNIVERSARY
CELEBRATION
1907·2007

LORD
BADEN·POWELL
OF GILWELL

2007

100TH ANNIVERSARY OF WORLD SCOUTING

Scouting started in England in 1907, based on the ideas of founder Sir Robert S.S. Baden-Powell and his book *Scouting for Boys*. Baden-Powell (1857–1941) was an accomplished British soldier who became a national hero for his service at the Siege of Mafeking during the Boer War. But he is better known for developing Scouting as a method for improving the physical and mental well-being of young people. His British program quickly spread and is now the largest voluntary youth movement in the world with 25 million members in 149 recognized national Scout organizations.

The Boy Scouts of America honored Baden-Powell, the Chief Scout of the World, in a painting commemorating his founding of Scouting. Here, American Scouts and leaders view a bust of Lord Baden-Powell along with Scouts from England, Scotland, Japan, and other countries.

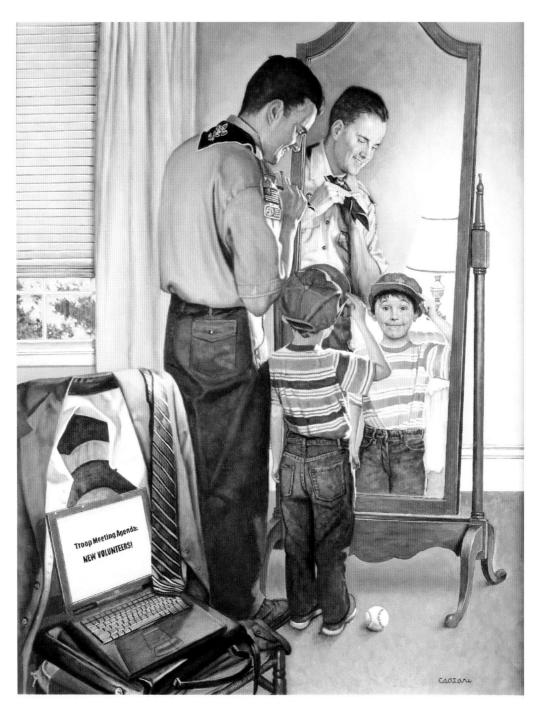

2008

YEAR OF THE VOLUNTEER

More than 1.2 million registered adult leaders around the country contribute their time and skills to the development of youth through Scouting. The 2008 painting is dedicated to those volunteers who give more than 288 million hours of service each year to 143,587 units in 321 councils in all 50 states. Here, a local leader is dressing for a Scout meeting; the screen on his laptop suggests that tonight's priority is to discuss recruiting new adult leaders to support the troop and keep it vibrant to ensure that the program will still be in place when his young son reaches Scout age. A recent poll found that 96 percent of Scout volunteers would encourage family and friends to volunteer with the Boy Scouts of America. After all, it's fun—"you get to be a kid again, in a way," says one volunteer.

2009

SCOUTING SALUTES COMMUNITY ORGANIZATIONS

Scouts need a place to meet, and this painting calls attention to the more than 124,000 Chartered Organizations in communities, which provide that home base. Scout units are owned and operated by "chartered organizations." These are volunteer fire companies, schools, churches, mosques, synagogues, and other civic groups that work in conjunction with local BSA councils to provide outreach programs for youth. The chartered organization arranges meeting facilities for the unit, provides leadership, and delivers support in the form of outdoor experiences, advancement, recognitions, and by promoting Scouting's values. Csatari included elements of his mentor's 1968 painting "Scouting is Outing" (page 92) in this illustration in the Scout at the window and the Scout troop "Meets Here" plaque near the door of the brick firehouse.

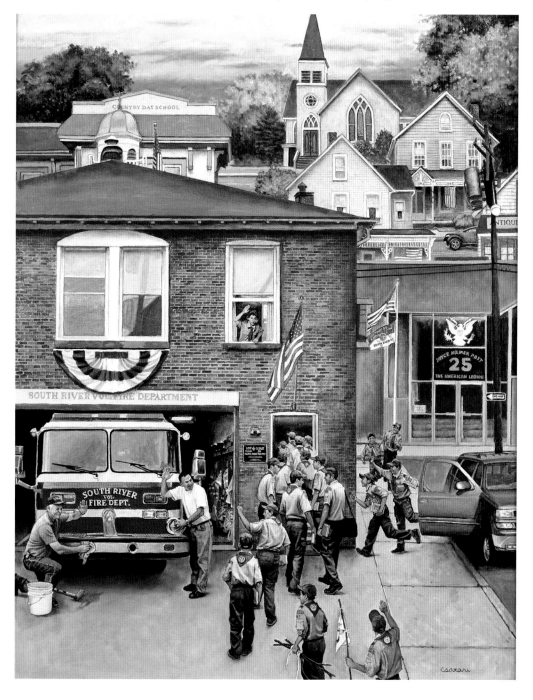

ARTWORK

The following paintings by Norman Rockwell are used with permission of the Boy Scouts of America.

1913 Scouting Makes Real Men
1918 The Daily Good Turn
1925 A Good Scout
1926 A Good Turn
1929 Spirit Of America
1931 Scout Memories
1932 A Scout Is Loyal
1933 An Army Of Friendship
1934 Carry On
1935 On To Washington
1935 A Good Scout
1936 The Campfire Story
1937 Scouts Of Many Trails
1938 America Builds For Tomorrow
1939 The Scouting Trail
1940 A Scout Is Reverent
1941 A Scout Is Helpful
1943 A Scout Is Friendly
1944 We, Too, Have A Job To Do
1945 I Will Do My Best
1946 A Guiding Hand
1947 All Together
1948 Men Of Tomorrow
1949 Friend In Need
1950 Our Heritage
1951 Forward America

The following paintings by Norman Rockwell are © Brown and Bigelow, Inc. and are used with permission of the Boy Scouts of America.

1952 The Adventure Trail
1953 On My Honor
1954 A Scout Is Reverent
1955 The Right Way
1956 The Scoutmaster
1957 High Adventure
1958 Mighty Proud
1959 Tomorrow's Leader
1960 Ever Onward
1960 Boy Scout Handbook Cover
1961 Homecoming
1962 Pointing the Way
1963 A Good Sign All Over The World
1964 To Keep Myself Physically Strong
1965 A Great Moment
1966 Growth Of A Leader
1967 Breakthrough For Freedom
1968 Scouting Is Outing
1969 Beyond The Easel
1970 Come And Get It!
1971 America's Manpower Begins With Boypower
1972 Can't Wait
1973 From Concord To Tranquility
1974 We Thank Thee, O'Lord
1975 So Much Concern
1976 The Spirit Of 1976

The following paintings by Joseph Csatari are © Brown and Bigelow, Inc. and are used with permission of the Boy Scouts of America.

1977 The New Spirit
1978 Scouting Through The Years
1979 Eagle Service Project
1980 The Reunion
1981 After Hours
1982 The Patrol Leader
1983 Family Camping
1984 The Strength Of Scouting Through Volunteers
1985 The Spirit Lives On
1986 It's A *Boys' Life*
1987 Values That Last A Lifetime
1988 Winter Camping Scene
1989 You Can Do It
1990 The Scoutmaster

The following paintings by Joseph Csatari are © Boy Scouts of America.

1991 Scouting For All Seasons
1992 Florida Sea Base
1993 A Good Turn
1994 A Scout Is Reverent
1995 Character Counts
1996 Pass It On
1997 Scouting Values
1998 Urban Good Turn
1999 Charles L. Sommers Wilderness Canoe Base
2000 Happy 90th Birthday BSA
2000 Out Of The Past Into The Future
2001 Jamboree 2001
2002 Reading Partners
2003 Prepared To Do A Good Turn
2004 Eagle Court Of Honor
2004 Dreams Become A Reality In Venturing
2005 Cub Scouts 75th Anniversary
2006 Scouting Heroes
2007 100th Anniversary Of World Scouting
2008 Year of the Volunteer
2009 Scouting Salutes Community Organizations

PHOTOGRAPHY

Boy Scouts of America, page 7, 10, 18/19, 7, & 84.
Boy Scouts of America/Roger Morgan, page 110/111.
Robert Byron Breese Jr., page 8.
Joseph Csatari page 14, 105, 106.
Wendy Csatari, page 148.
Louie Lamone, page 108.
Philip Scalia/Alamy page 4.

Cover: author photograph, Joseph Csatari Jr.

Every effort has been made to trace the copyright holders and the publishers appologise in advance for any unintentional omissions. We would be pleased to insert the appropriate acknowledgement in any subsequent edition of this publication.

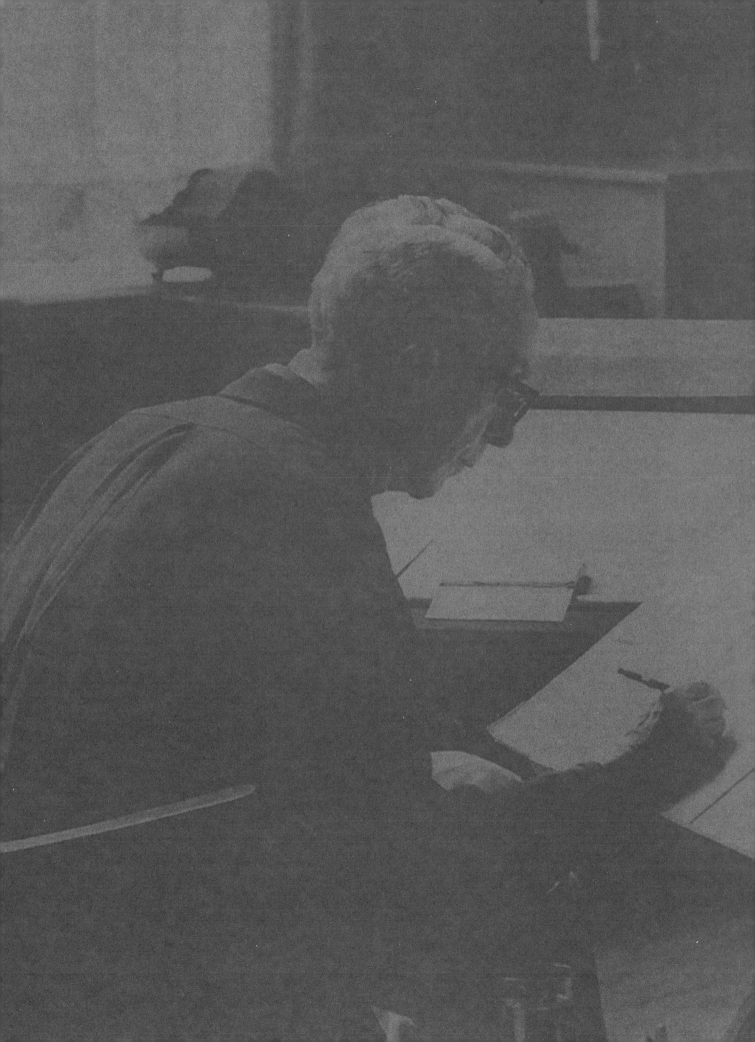